# The Secret Life of Mandalas
# A Coloring Book with Inspirational Poetry

Melba Christie

Copyright © 2016 Melba Christie

All rights reserved.

ISBN:1537017497
ISBN-13:978-1537017495

# DEDICATION

I dedicate this book to my family. Their support is unconditional:

To my husband who was very supportive and gave me the time and space I needed to work on my project.

To my dear mother in-law who inspired me to follow my dream. She encouraged me every step of the way.

To my sister who has been my mentor all my life.

To my children who make me proud every day and inspire me every day.

To my grandchildren who fill my heart with the greatest joy.

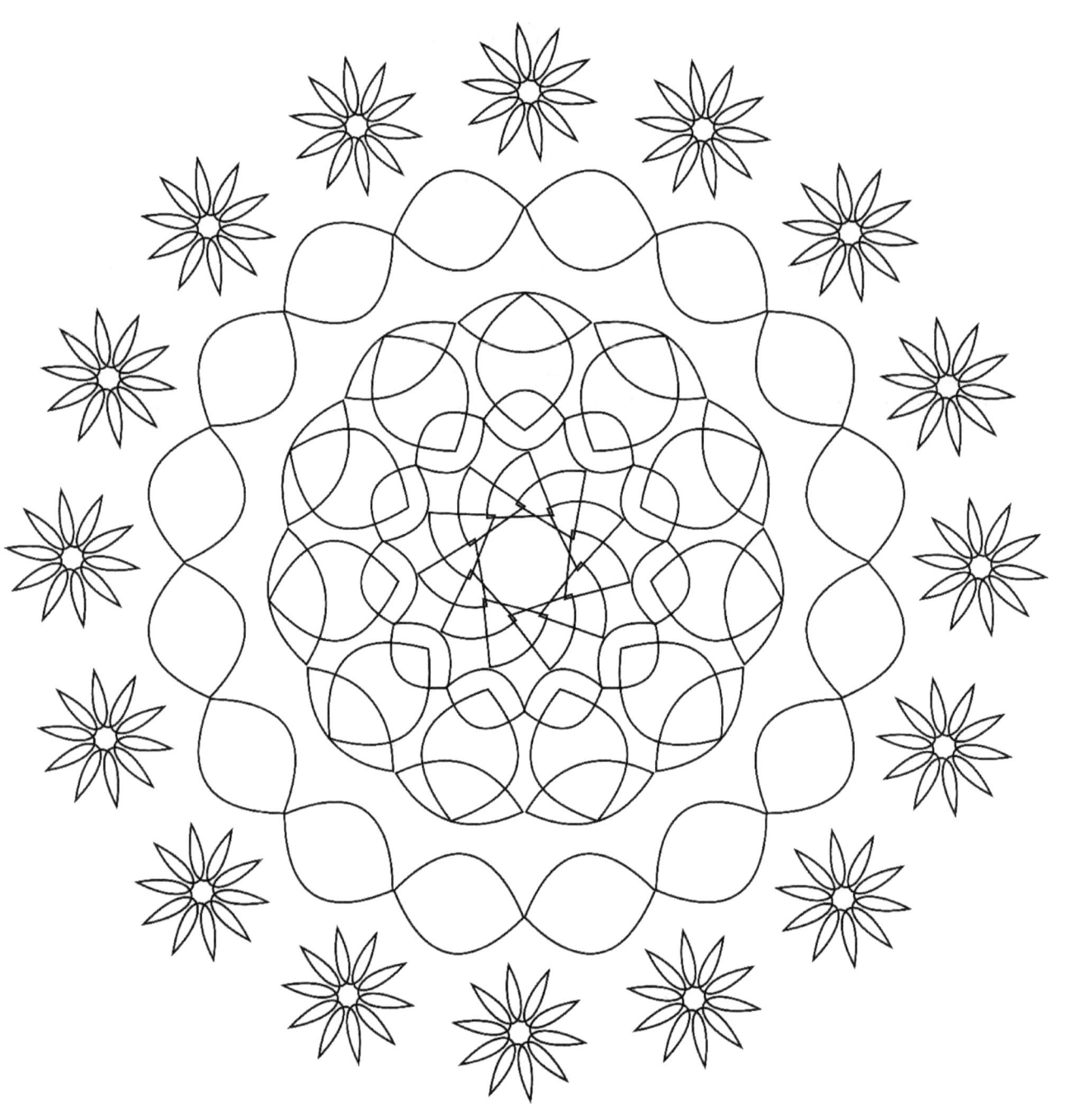

"As the sun colors flowers, so does art color Life."

-John Lubback

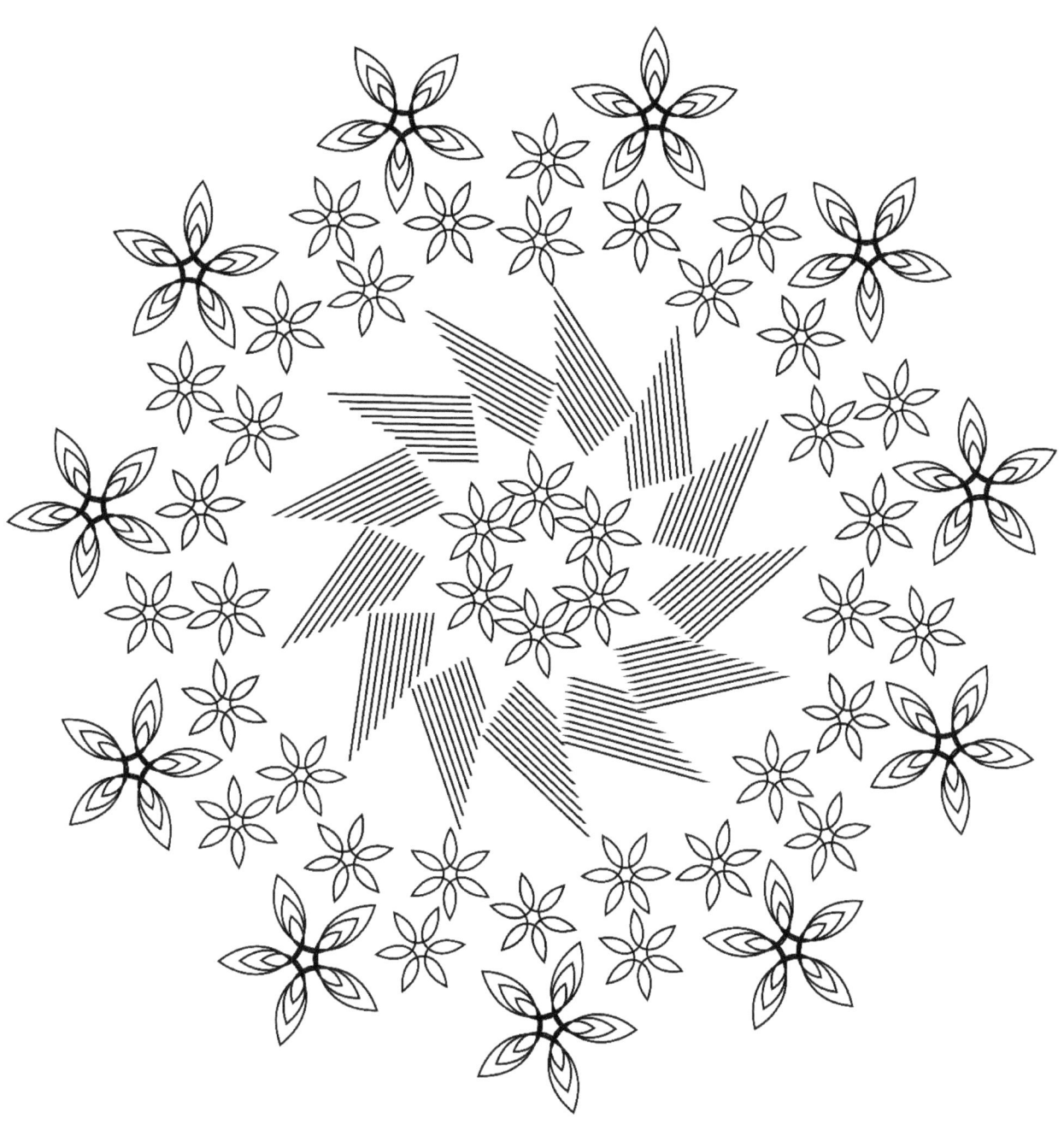

"Look at the painting and listen to the wind"
- Haruki Murakami

# ACKNOWLEDGMENTS

I would like to thank the teachers who helped me see the world from a creative perspective. Thanks to my literature teachers who taught poetry with love and devotion. Thanks to my parents who instilled in me love for their native language, Spanish, so I would learn about the great Puerto Rican poets and writers. I would also like to thank Dr. Wayne Dyer for his inspirational messages. They helped me get over some difficult times. Above all I would like to thank God for guiding me always.

"Most mandalas have an intuitive, irrational character and, through their symbolical content, exert a retroactive influence on the unconscious. They therefore possess a "magical" significance, like icons, whose possible efficacy was never consciously felt by the patient."

-Carl Jung

The Secret Life of Mandalas: A Coloring Book with Inspirational Poetry

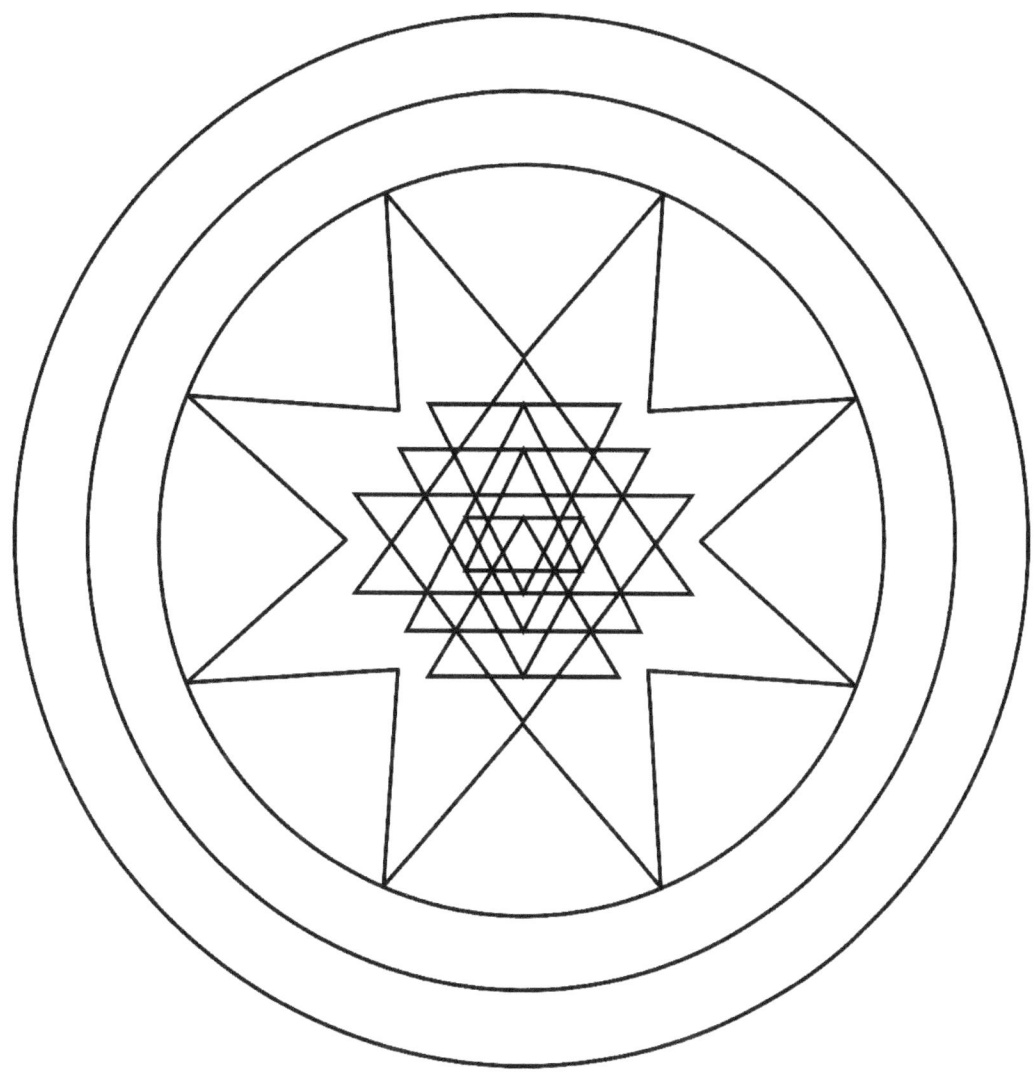

"The world is but a canvas of the imagination."
Henry David Thoreau

Melba Christie

# 1 INTRODUCTION

The title of this book The Secret Life of Mandalas came to me in a dream. I suppose it is because I have been reading so much about mandalas lately. What I remember of my dream is that I was meditating and when I looked up to see what time it was, I noticed the face of the clock turning into different colors. It was hypnotizing. The colors turned into flowers and they morphed into all kinds of shapes and figures. I knew I was dreaming but at the same time I was fully aware of this fascinating transformation. My dreams are usually vivid and colorful. I tell people all the time that my dreams are in Technicolor. Today they are most probably in high definition. My dreams take place in real time. I dream about places unknown. Then a few days later I find myself in the very same place; it is really uncanny.

The peaceful, colorful landscapes I move in during my dreams are breathtaking. When I wake up I immediately pick-up my sketch book and start drawing what I remember. The dream inspired my drawing and designing, creating this coloring book that fulfills a longtime dream. I also wanted to publish my poems. I decided to put together my passion for art and poetry. I knew that this was something I just had to do.

I meditate almost everyday. My inspiration came from a video by actress Shirley MacClaine called **The *Inner Workout*.** The video used the mandala as the focal point for meditation.

I remember being mesmerized by the different hues and intricate patterns within. Little did I know then I would be publishing a coloring book for adults using mandalas I created myself.

Coloring was my favorite past-time as a child. I recall how excited I was on my ninth birthday when my aunt gave me a huge coloring book and a box of 64 Crayola™ crayons. She thought I would reject the gift because in her mind I may had out grown coloring books. When she told me she would exchange the box for something else if I did not like my gift, I immediately said no. I remember that I took such good care of my crayons. I used them until they were so small I could barely hold them. I liked to color so much

because my father, older brother and nephew all drew beautifully. I was surrounded by art. However, I believed I could never draw anything the way they did. So I conformed to coloring.

Adult coloring books cover a wide spectrum of themes and topics. Coloring has become so popular that many apps have been developed for smart phones and tablets. Personally, I prefer to draw and color on paper or in my art journal.

Drawing mandalas helps me be more relaxed and creative. The research suggests that coloring is beneficial to your health. Mandalas have a long cultural, artistic and religious history behind them. Mandala pronounced /maendala/ is the Sanscrit word for circle. The root "manda" means essence and "la" means container. However, a mandala is more complex that just a circle or container. The mandala has come to symbolize the never ending cycle of life. It represents the universe and nature.

According to Wikipedia, the mandala is "a spiritual and ritual **symbol in Indian religions**, representing the universe. In common use, "mandala" has become a generic term for any diagram, chart or geometric pattern that represents the cosmos both metaphysically or symbolically; a microcosm of the **universe**."

Mandalas represent beauty, nature, love and harmony. As you become more aware of nature and your surroundings you will discover that mandalas can be seen everywhere. You will begin to connect ideas and to focus with greater clarity. This clarity will lead to more creativity and fulfillment.

Learning how to meditate using mandalas fosters well-being and relaxation. Most of us lead busy and in many cases very stressful lives. It is easy to get lost in the turmoil of the demands of our jobs, careers, family life and relationships impose upon us. As we engage ourselves in coloring or painting mandalas, we start to build a special kind of muscle. We strengthen our center and begin to notice the development of more positive and creative thinking. Positive thoughts evolve into better health. Creative thoughts helps your brain.

The concept of the mandala became better understood by me when I taught middle school and was invited to participate in a project at my Alma Mater. *The Mandala Project* involved hundreds of students from different urban and suburban schools. My urban students were given white boxes on which they were allowed to draw whatever they

wanted. They were also asked to write on a piece of paper any thought, quote, feeling, wish, or problem they wanted to solve and place it inside the box. They formed a huge mandala with the boxes and then they aligned themselves within the concentric circles that were formed. The focus of the activity was to start a conversation about unity and peace. It was a beautiful experience for them and for me.

The mandalas I created for this coloring book have a specific meaning to me. I use flowers and geometric figures. I tried to align some of my Haiku poems and some stanzas from my poems with the drawings in the hope that they bring you relaxation. *"A Haiku poem is a traditional form of **Japanese poetry**. Haiku poems consist of 3 lines. The first and last lines of a **Haiku** have 5 syllables and the middle line has 7 syllables. The lines rarely rhyme."* However, some of my Haikus do not use the traditional format. My poems in general focus on everyday thoughts and events. For me *poetry is life and life is poetry*. I feel the same way about art. I selected some of my favorite quotes from the artists and poets I admire and used them as inspiration.

Once you color each mandala, it will probably have a more personal meaning for you. It will become your creation. You might even feel you are more centered spiritually. This is why I believe the Mandala has a secret life. Behind each one is a message and it becomes clear to each of us in a unique way. Mandalas are used in religious rituals and as the focal point for prayer and meditation. Many believe this helps to bring stillness and calm. Use the colors that speak to you. Everyone has a favorite palette.

I am not so bold as to think my mandalas will help you find your center or make you more aware of nature. I hope you simply have fun coloring them and reading my poems and pondering on the quotes I selected. I have also listed a few books for further reading on mandalas.

The mandala's secret life will be revealed to those who truly believe that coloring connects us to a better sense of self. Each one will convey a special message.

As I mentioned before I come from a family of artists. I never thought that what I drew was good enough. I wrote more than I drew but I envisioned myself in front of an easel drawing something important someday. Unfortunately those family members have all passed now. I could imagine how surprised they must be with this book. I hope they are also proud.

I still do not consider myself an artist. I do not have an art degree. But the beauty of these art forms is that you do not necessarily have to be an artist. Picasso once said, "Every child is an artist, the problem is how to remain an artist once we grow up." Fortunately, I *did* remain hopeful that maybe I could be an artist some day. I never studied art formally but I bought art books and subscribed to different artist magazines to gain techniques and to help me develop my skills.

Thus, I have combined the two things I love to do in this coloring book. I hope you enjoy my poems and my drawings. I would love to get your feedback. You can read more of my poems on my website [MelbaChristieatPoemattic.com](MelbaChristieatPoemattic.com). ***Happy Coloring!***

The Secret Life of Mandalas: A Coloring Book with Inspirational Poetry

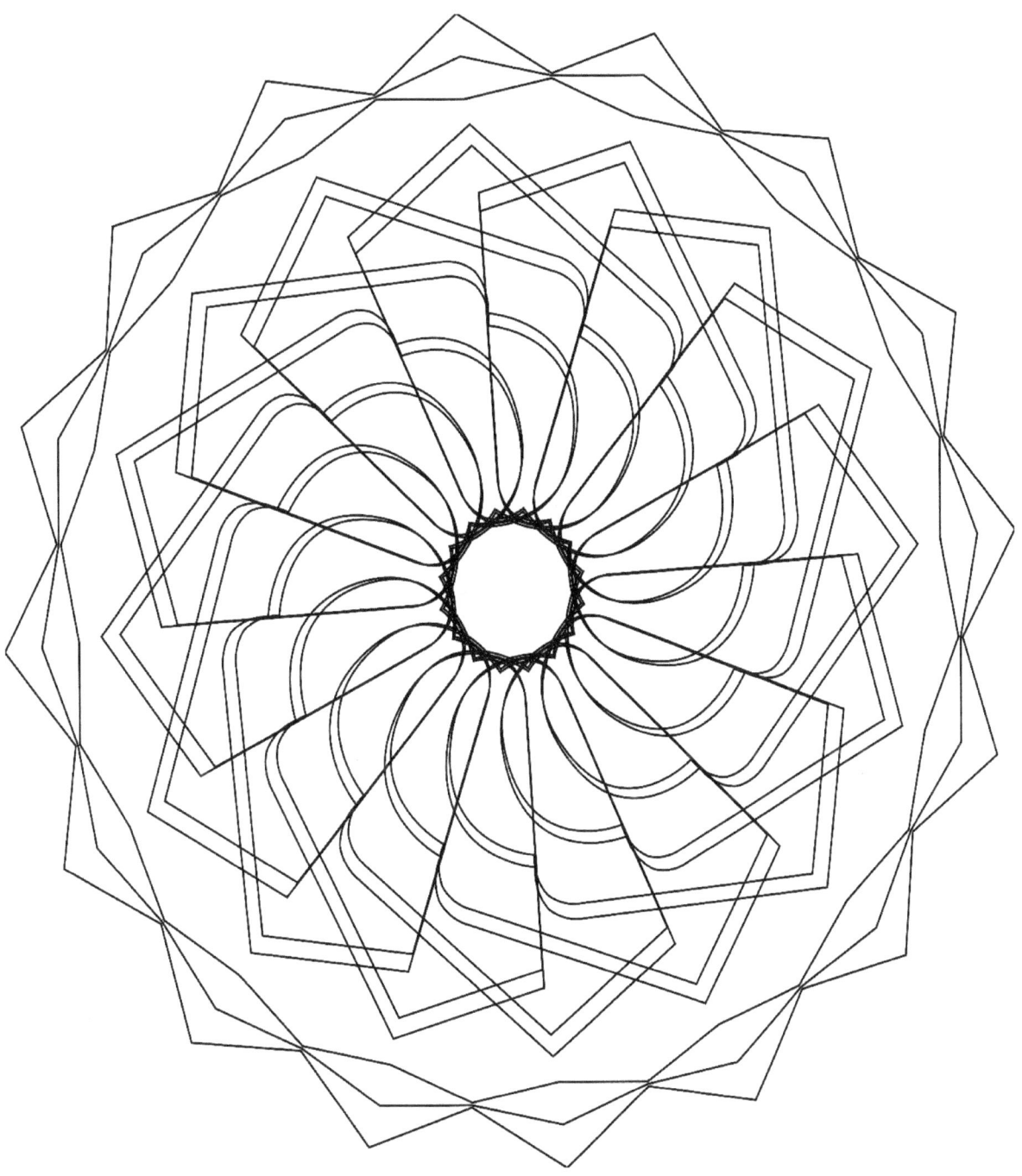

"You can't use up creativity. The more you use, the more you have."

-Maya Angelou

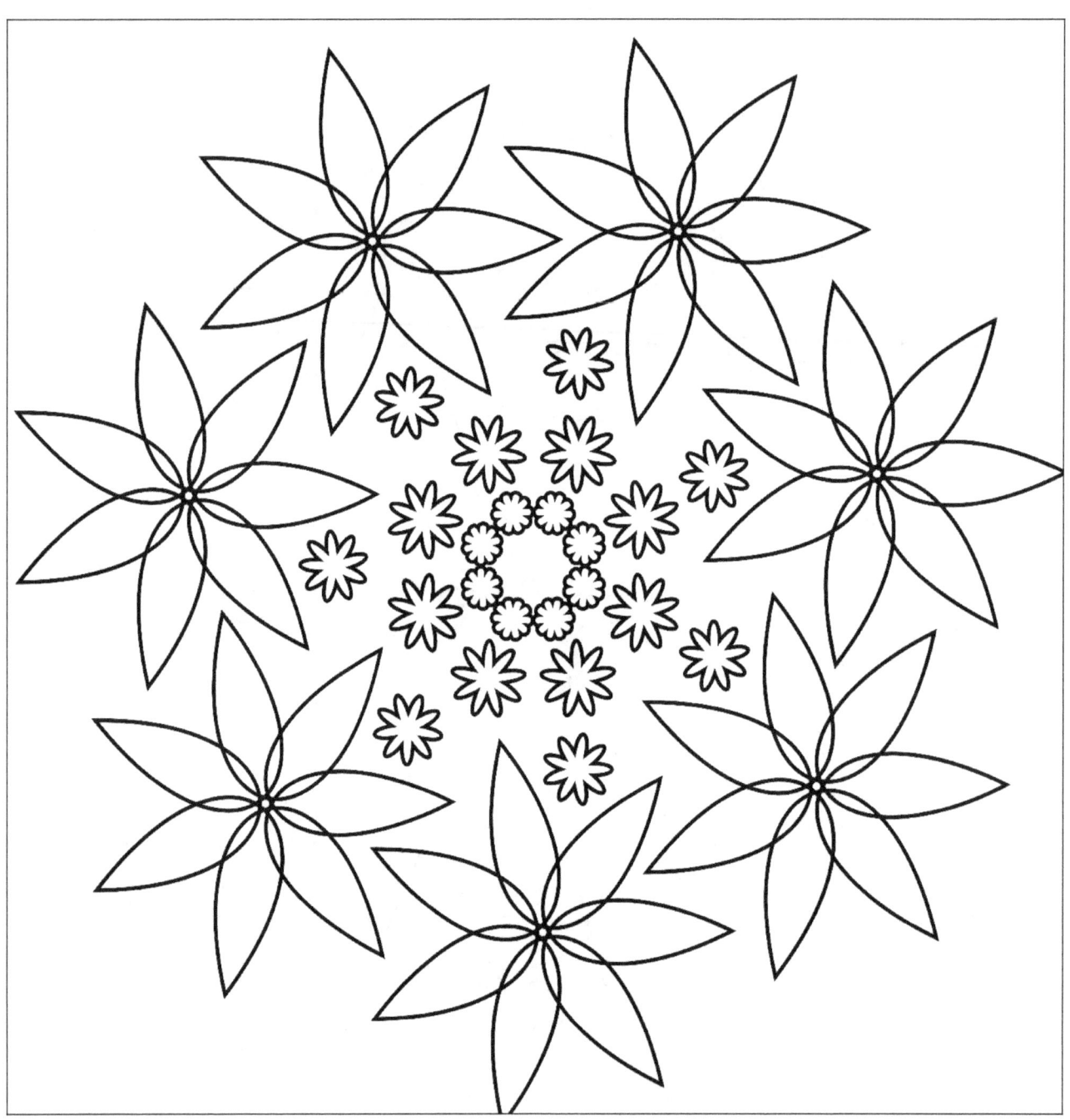

"I saw a sunset in Queretaro that seemed to reflect the color of a rose in Bengal."

-Jorge Luis Borges

# 2 MY POEMS

## *A Poem to Celebrate Me*

Today and *only* today

for now anyway

I want to celebrate my life.

I want to celebrate right now,

who I have become,

who I was,

and who I am right this very minute.

Why?

Because it is easy to forget these things;

we often forget that life is too short;

I want to celebrate my life right now!

This poem is to celebrate

the Now,

*this* very instant,

the essence of this second,

the miracles that happen within a minute's time,

like the birth of a child,

or the reviving of a life.

I want to celebrate the number of breaths

that have been programmed just for me.

We are all given only certain number

of breaths during our lifetime you know.

I want to celebrate the first and the last one now!

I cannot remember the first and do not know when the last will be.

In the meantime, I want to celebrate

my poems,

the letters that gave life to my words,

the thoughts that gave life to me,

and the **Force**

that made me think about

*who I am now.*

I want to celebrate

today and only today

for now anyway.

What I celebrate tomorrow

will depend on today.

I continually think about what inspires me and what inspires my writing. Sometimes what inspires me is a simple line in a **poem** or narrative. Sometimes it's the title of a poem. Some poems stay with us forever. **The poem that follows is a poem inspired by great titles.**

<u>*It's all I have to bring today*</u>

*It's all I have to bring today*

can you tell what it is?

It's …*The Look,* you say,

Well, by the way, you're right.

I could not stay away.

So I took

*The Road Not Taken*

by the others for fear of rejection.

Our love is unique

*For "Now and Forever"*

in *all Dreams*

and in all the hours of the day

*The Layers*

of moments spent making it work.

Our love, my love is here to stay.

*When I Consider Everything that Grows*

I know that nothing is impossible

because …there are always *Miracles*

to count on

*Oh Me! Oh My!*

Life is good*!*

Melba Christie

## What Connects Us?

The blue sky connects us;

trees connect us,

raindrops connect us,

the beautiful songs of birds,

the fluttering of a butterfly,

and the buzzing of a bumble bee,

connect us.

When we breathe in

and when our hearts beat

we are even more connected.

Let's take advantage

of the connectivity

**and pray for peace.**

\*\*\*

## Field of Daisies

I wandered into

a field of Daisies

quite accidentally.

I wondered why

I was so lucky

to deserve

such ecstasy.

I know now

how it feels

to be a bumblebee!

\*\*\*

## Mi Amor

El color de un verdadero amor

se esconde detrás de un arcoiris mañanero

para sorprendernos cuando

menos lo esperemos.

\*\*\*

## Deseo

Anoche platicaba con una estrella
Para pedirle que iluminara
el camino directo a tu corazón.

\*\*\*

## Sueño
Recordar es vivir dice la canción.
Hoy recuerdo el sueño
Que vino en un barco en busca de su libertad.
El anhelo común para muchos
y que bueno que de esa esperanza sublime
naciera yo.

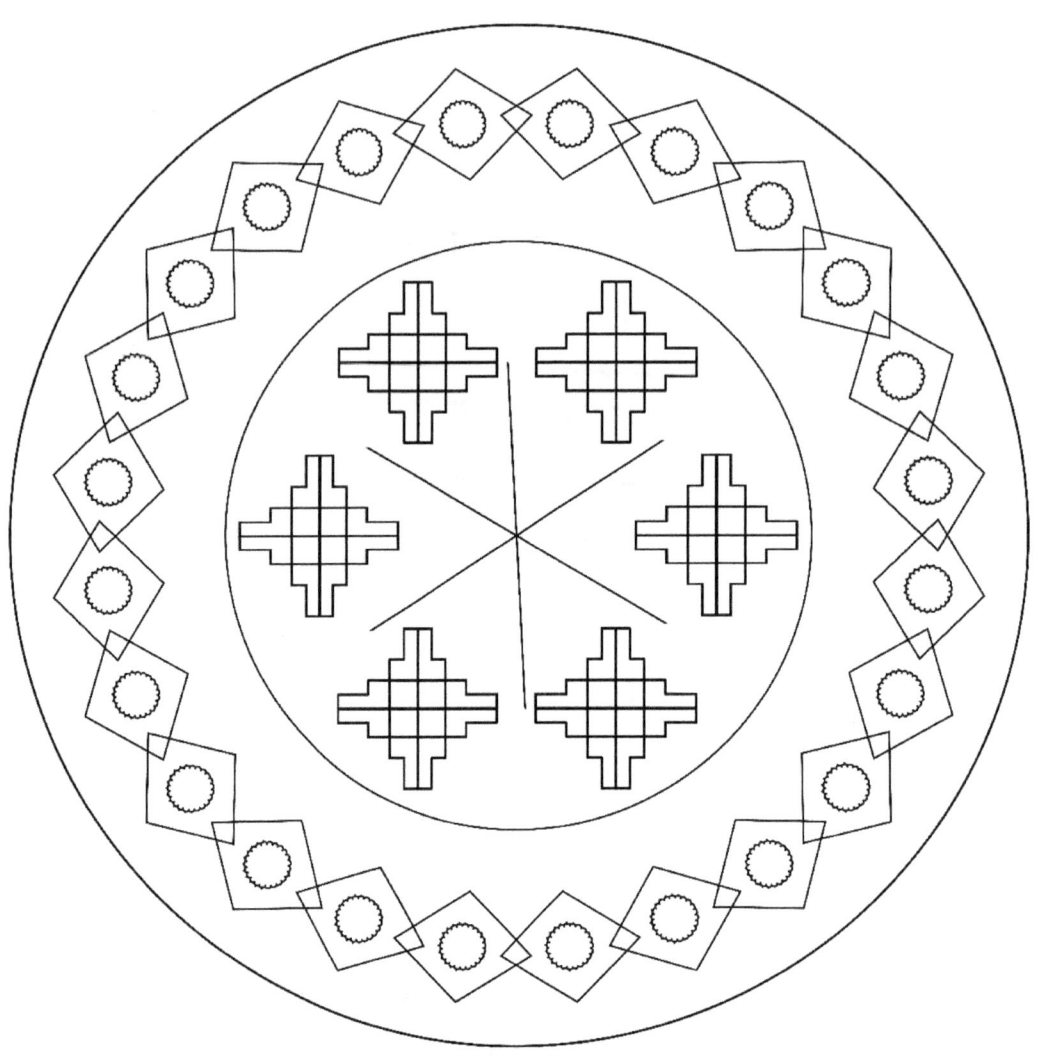

"All great art is a visual form of prayer."

-Sister Wendy Beckett

## 3 MY HAIKU POEMS

*Rocky road unravels*

*The soul's journey through life*

*Final stop unknown*

\*\*\*

The landscape whispers.

Exotic and luscious

red grapes cuddle.

\*\*\*

### Grace is Amazing

Hearts and souls rejoice

Hatred, *Be* not proud!

\*\*\*

Weeping willow mourns

its fallen branch after the storm.

**Sunshine peeks through.**

\*\*\*

**Heart beats tell time well**

**Love grows wildly**

**At first sight a new life imagined.**

\*\*\*

Disappointment

breaks my heart today

then I hear our song

\*\*\*

Words unspoken live

in solitude and in grief.

Where are my angels?

\*\*\*

Keeper of secrets:

only this paper and pen

**will know the truth.**

\*\*\*

**A heart full of love,**

**a house of refuge for all,**

**a mother's hug!**

\*\*\*

Las Margaritas

Divino Tesoro

Amanece!

\*\*\*

Sun rays seem to slice

Through the blue of my soul

God guides the way

\*\*\*

Someone perfectly

aligned the exact number

of white petals.

A flower bloomed

to delight my view.

\*\*\*

An artist looked deep inside my heart

And tried to paint its sadness

But he knew I'd rather hide the melancholy

So instead the artist painted

Bright stars

to guide me through the night.

\*\*\*

Be you uniquely

One of a kind forever

A lotus blossoms

\*\*\*

# 4 TIME TO COLOR YOUR STRESS AWAY

**Colors are smiles of nature.**
Leigh Hunt

Coloring your mandala will be an adventure. Plan your palette using your favorite shades and hues. However you may want the colors to signify specific moods, feelings and personal beliefs.

## The Meaning of Colors in a Mandala

- White = Purity, focus
- Pink = Love, Compassion
- Green – Love of Nature
- Blue = Peace
- Red = Fortitude
- Yellow = Knowledge, Laughter, joy
- Orange = Creativity, Self- Awareness
- Black = Individualism

If you use watercolor pencils you might want to experiment and mix different colors to get the gradient or shade you want to achieve. Gels pens are great for coloring. They come in such a variety of shades and neon colors. Color *dangerously* and pick colors that you never use. You will be surprised at how some colors go together naturally.

"Nature always wears the colors of the spirit."

- Ralph Waldo Emerson

"Love was a feeling completely bound to color, like thousands of rainbows.."
-Paulo Coelho

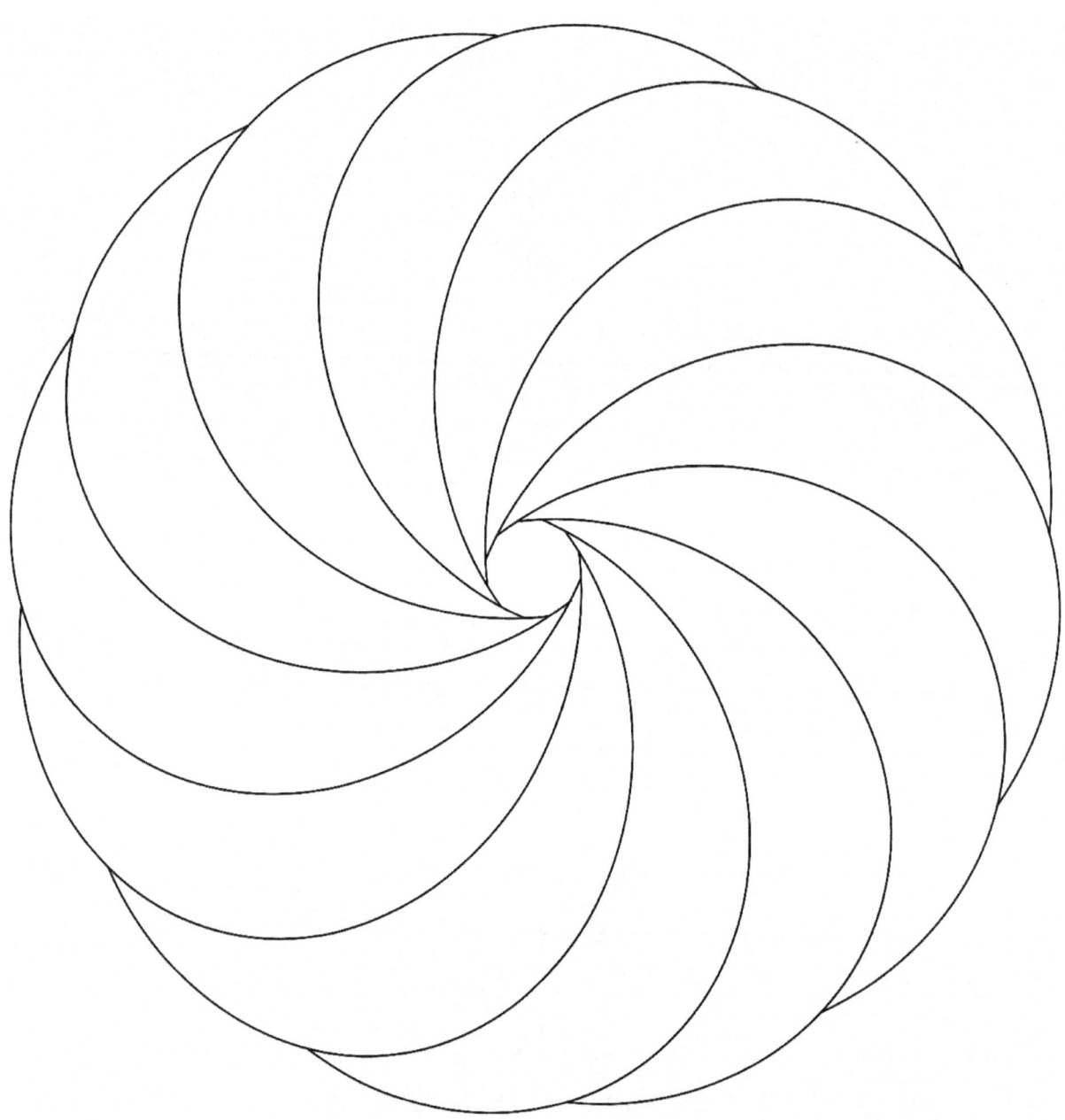

"Why stop dreaming when you wake up?"

-Unknown

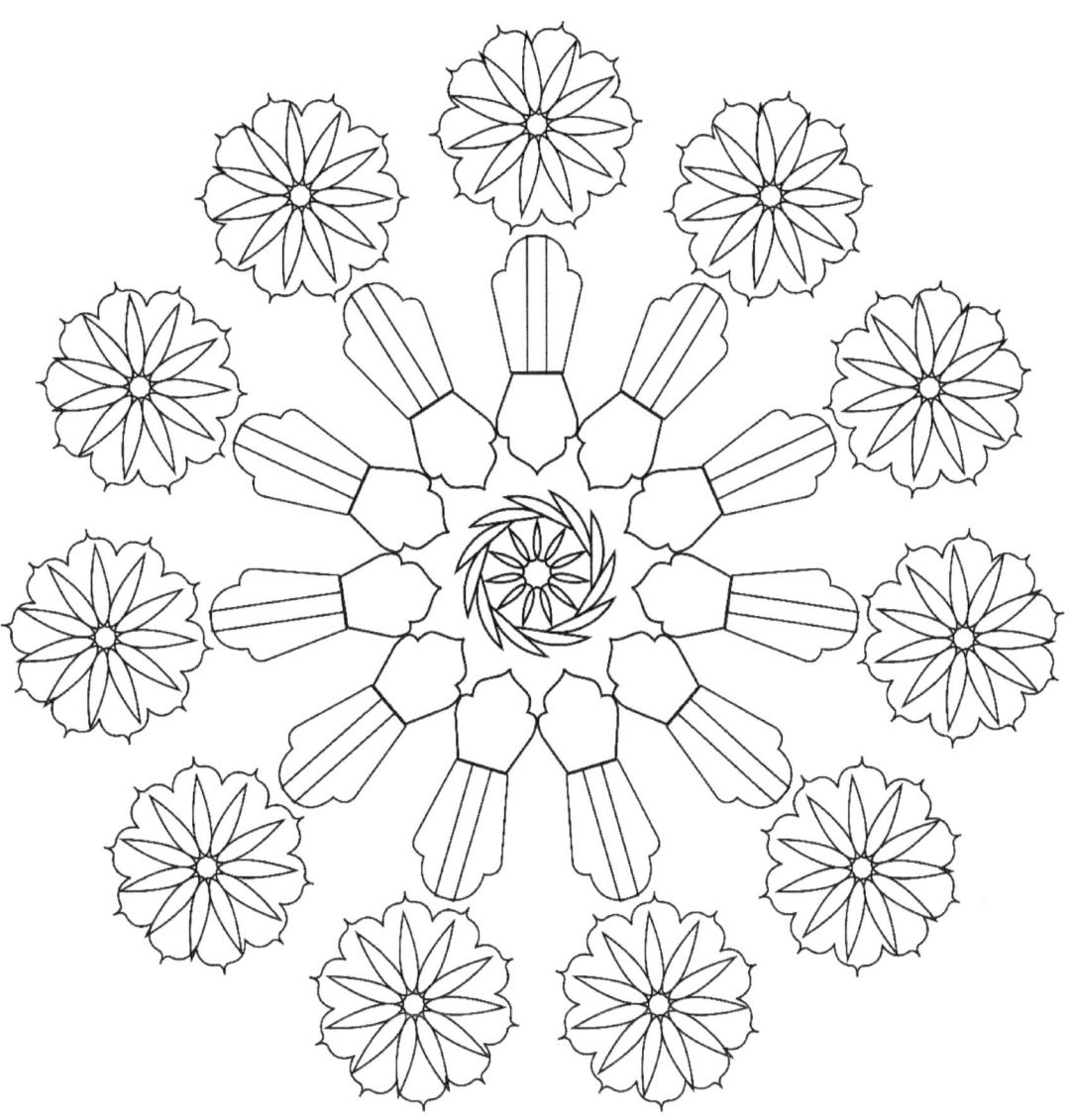

"I paint flowers so they will not die."

Frida Kahlo

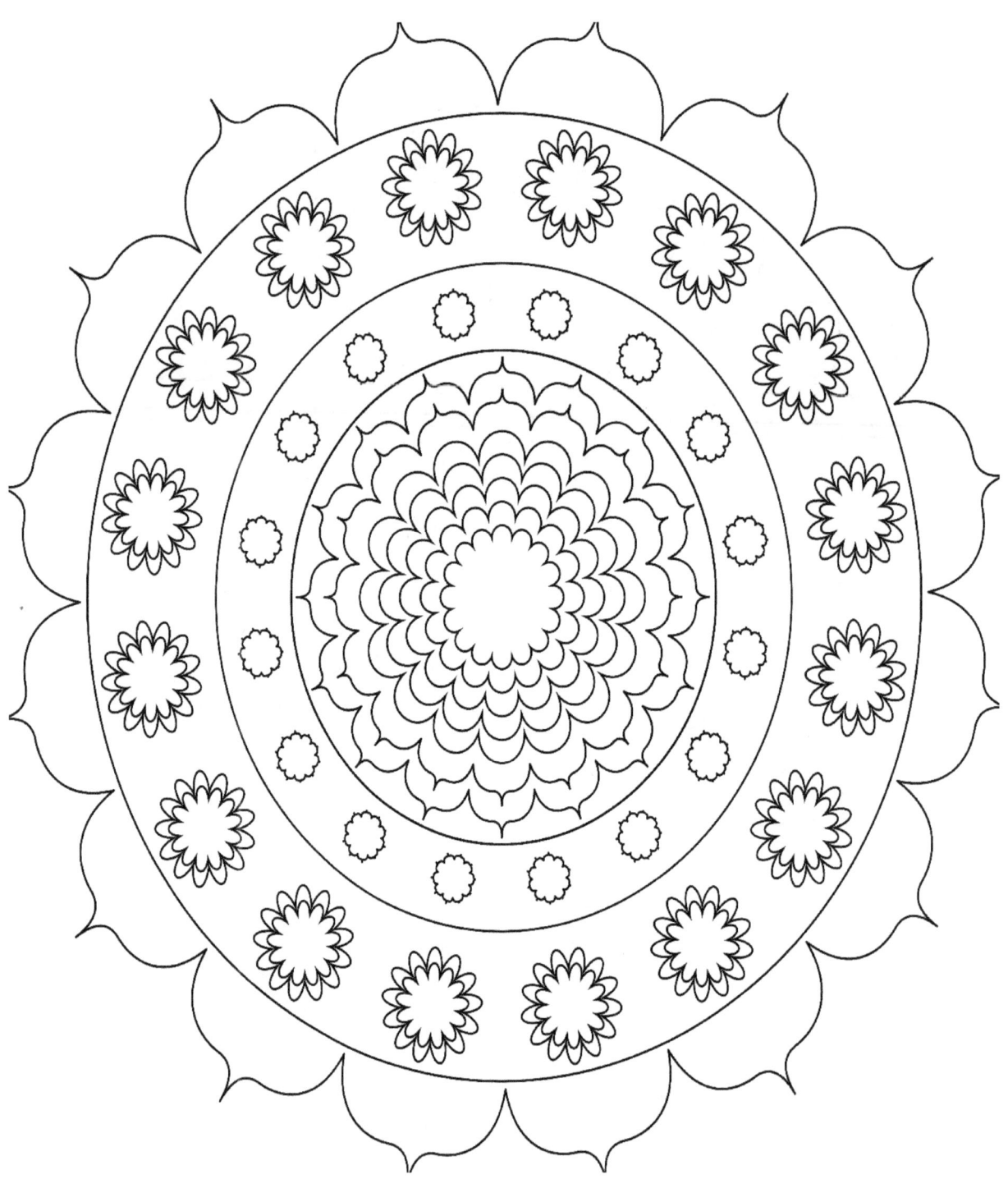

"The appearance of things change according to the emotions and thus we see magic and beauty in them, while the magic and beauty really are in ourselves."

- Kahlil Gibran

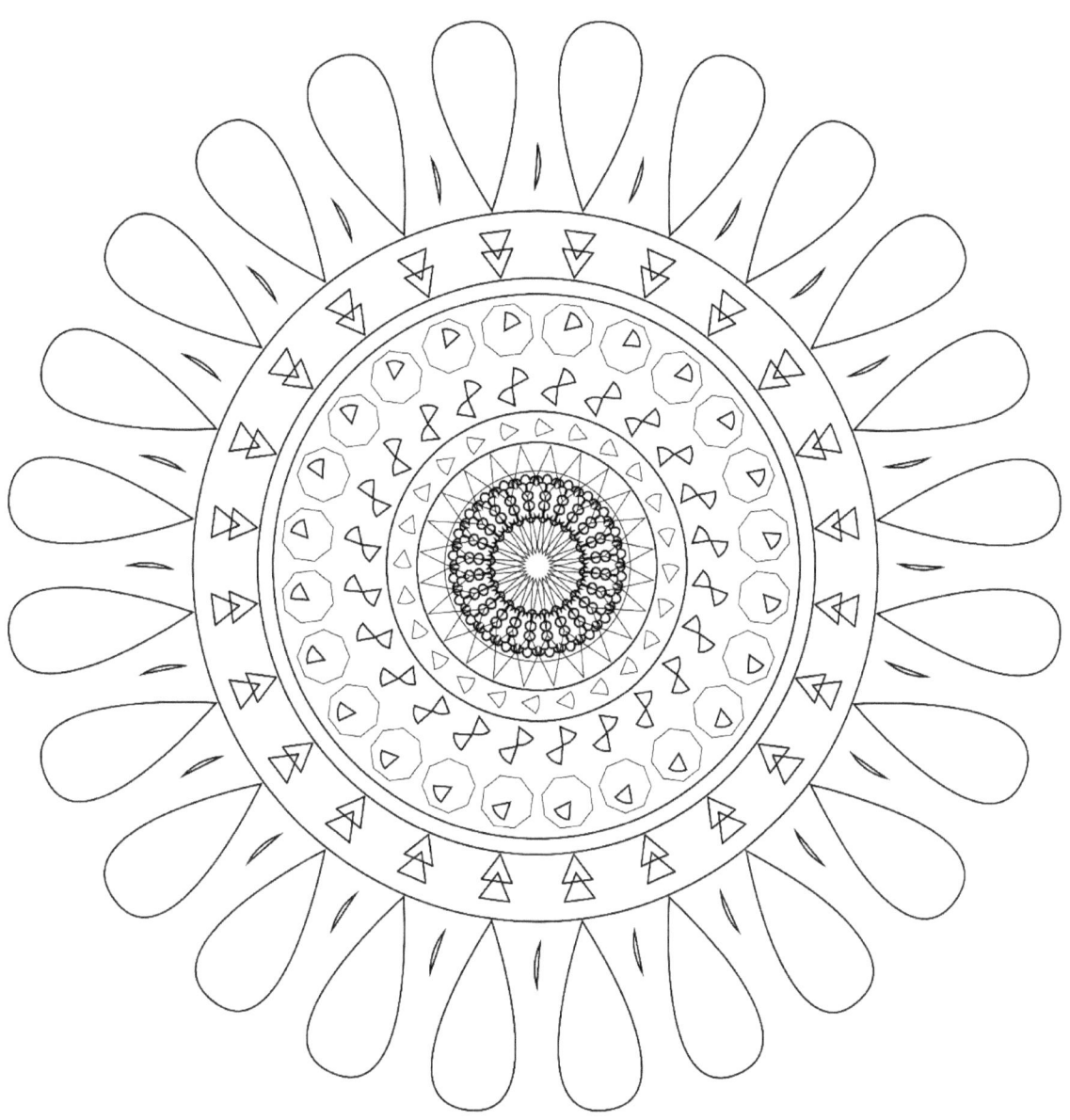

"Green is the prime color of the world, and that from which its loveliness arises."

-Pedro Calderón de la Barca

"To see the Summer Sky is Poetry,

though never in a Book it lie –

True poems flee."

- Emily Dickinson

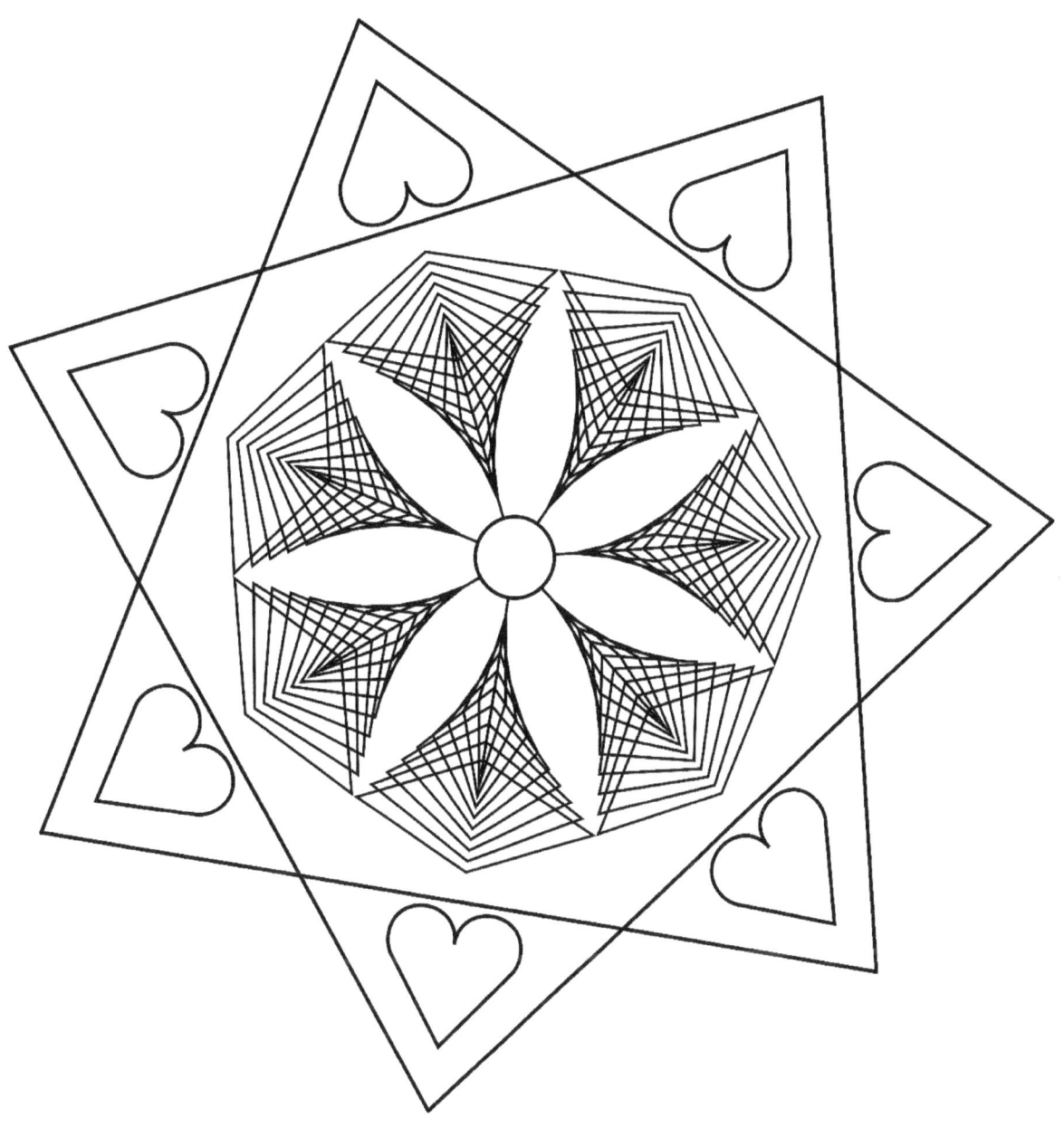

"All that we love deeply becomes a part of us."

-Helen Keller

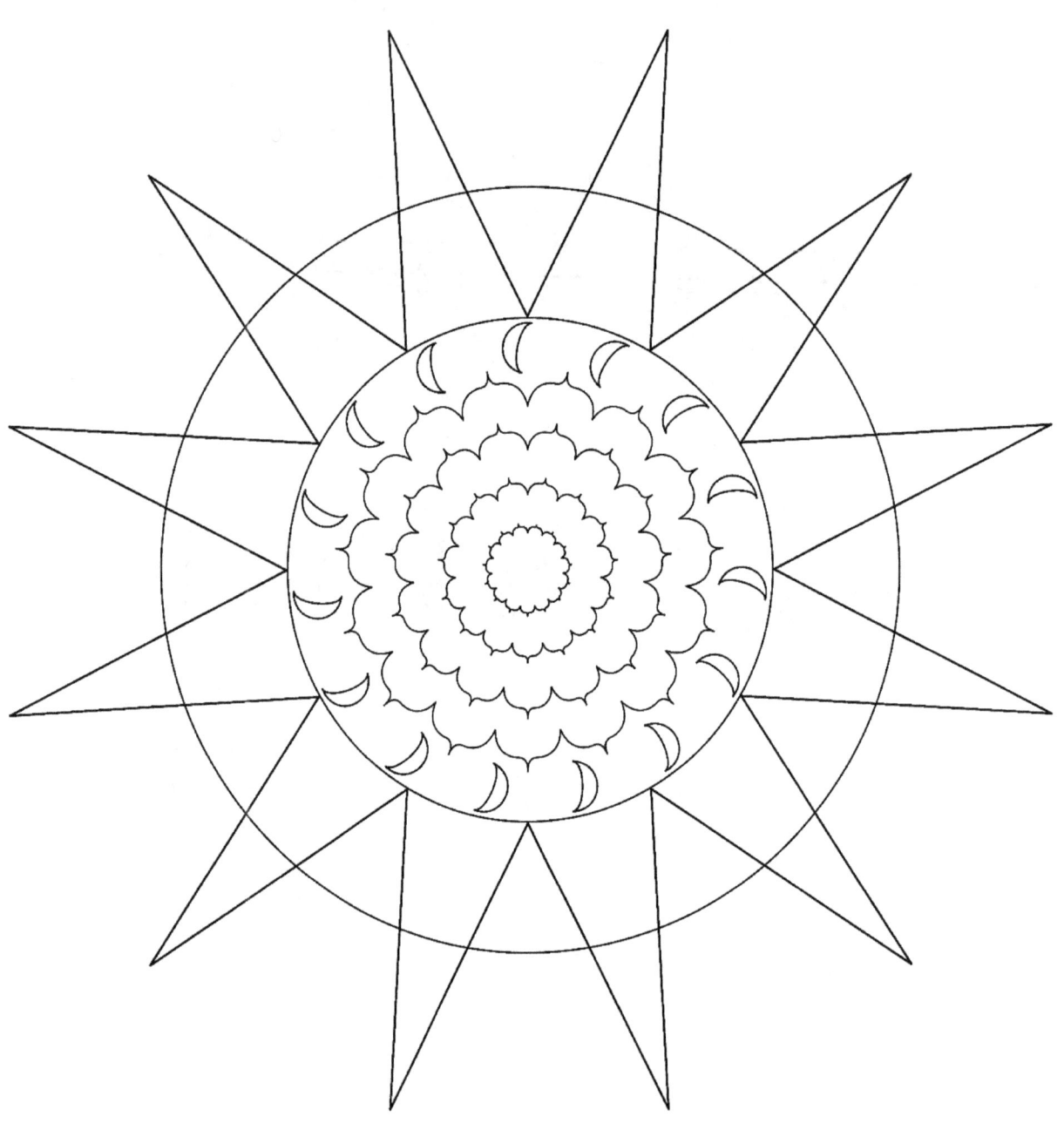

"Everything you can imagine is real."

-Pablo Picasso

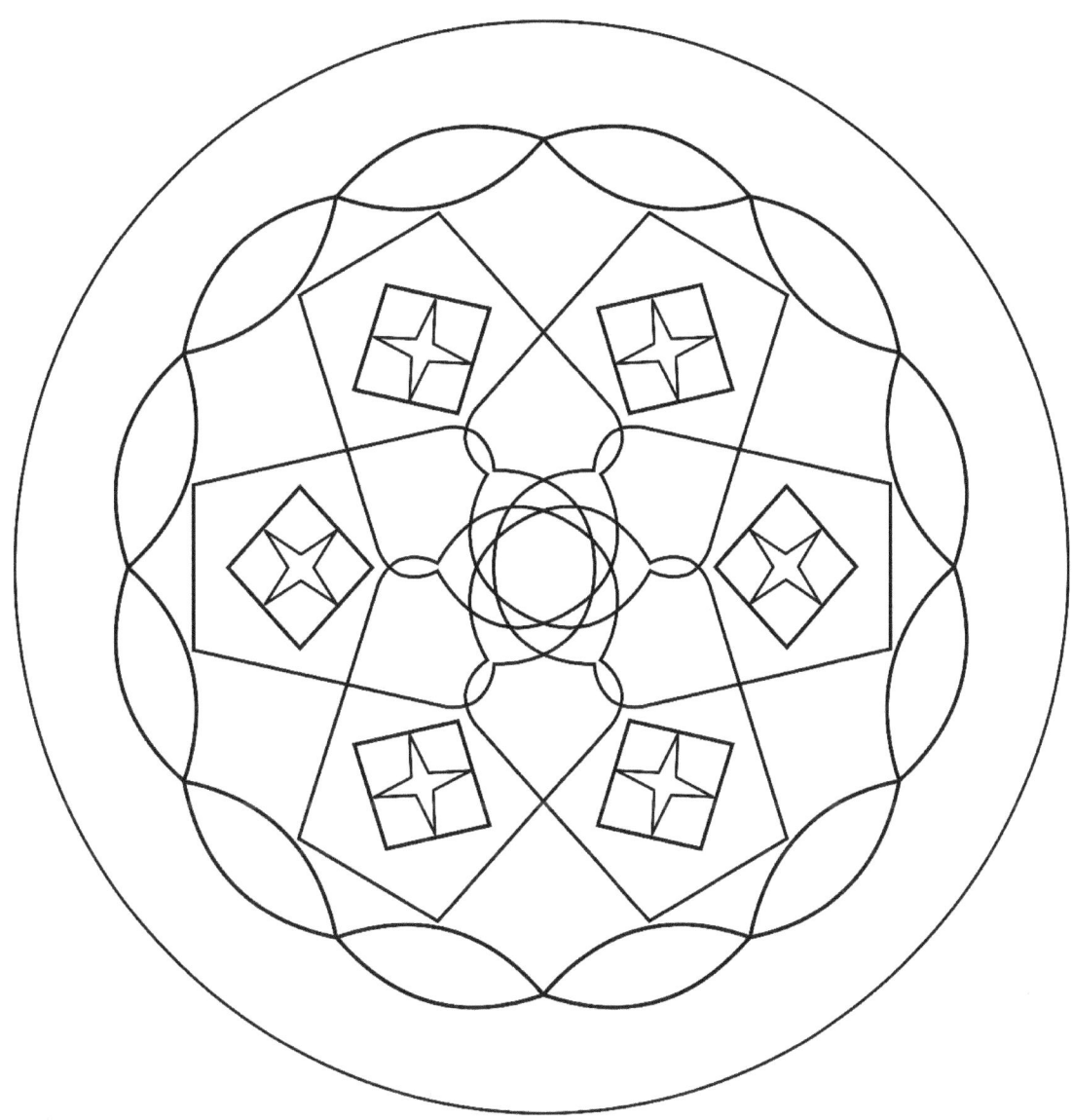

"In our life there is a single color, as on an artist's palette, which provides the meaning of life and art. It is the color of love."

- Michelangelo

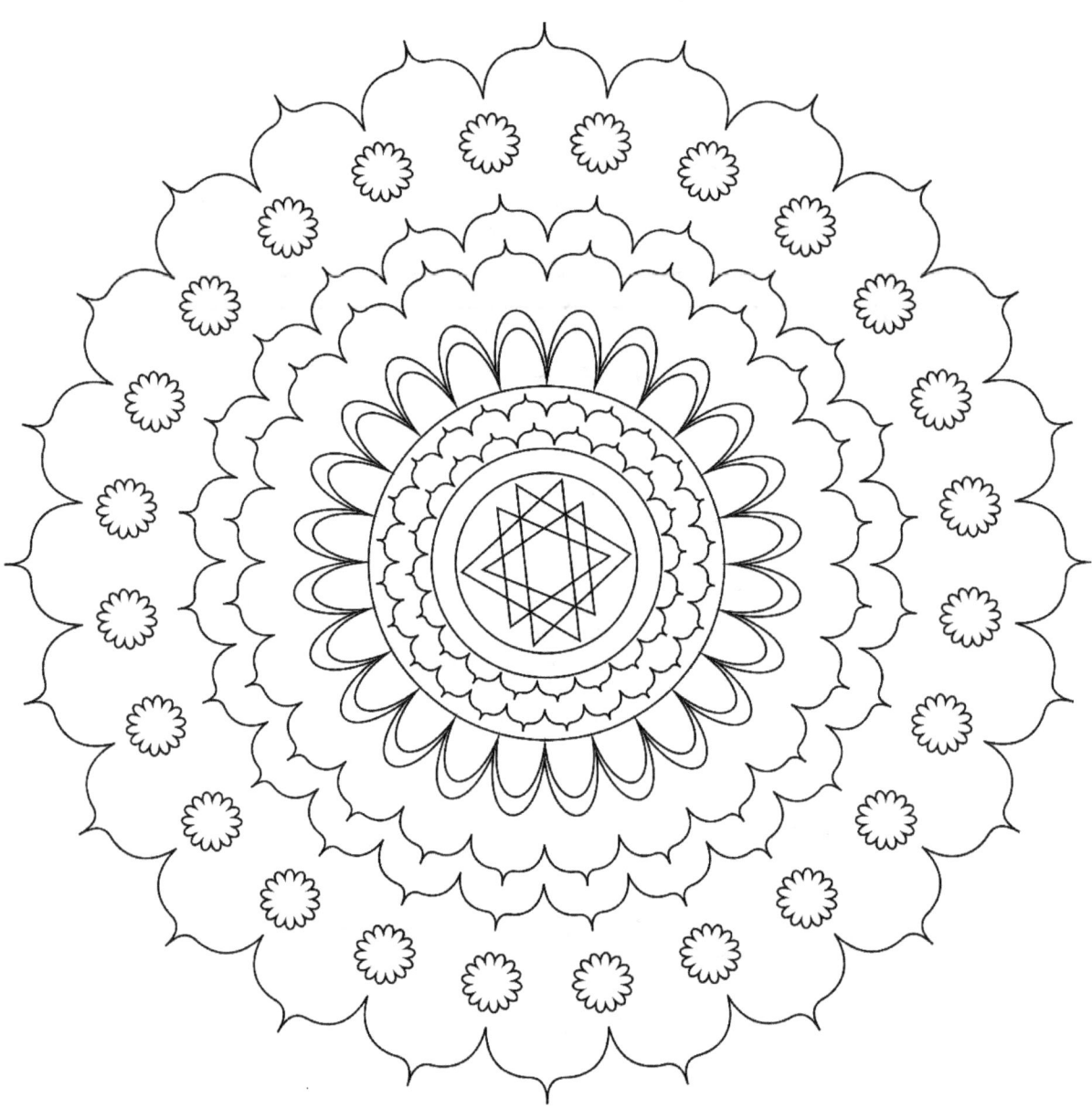

"Throw your dreams into space like a kite, and you do not know what it will bring back, a new life, a new friend, a new love, a new country."

- Anais Nin

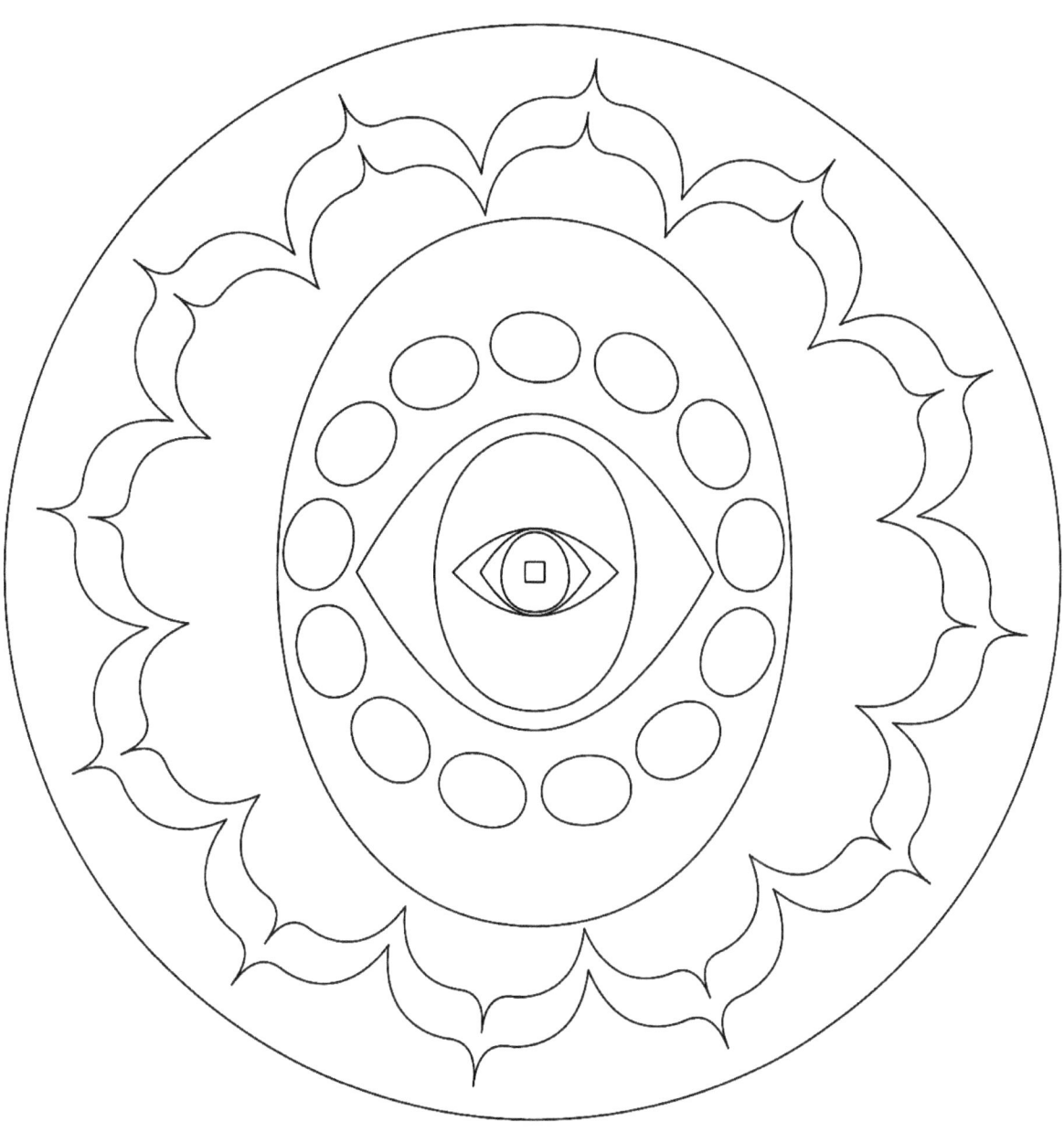

"Poetry is an echo, asking a shadow to dance."

-Carl Sandburg

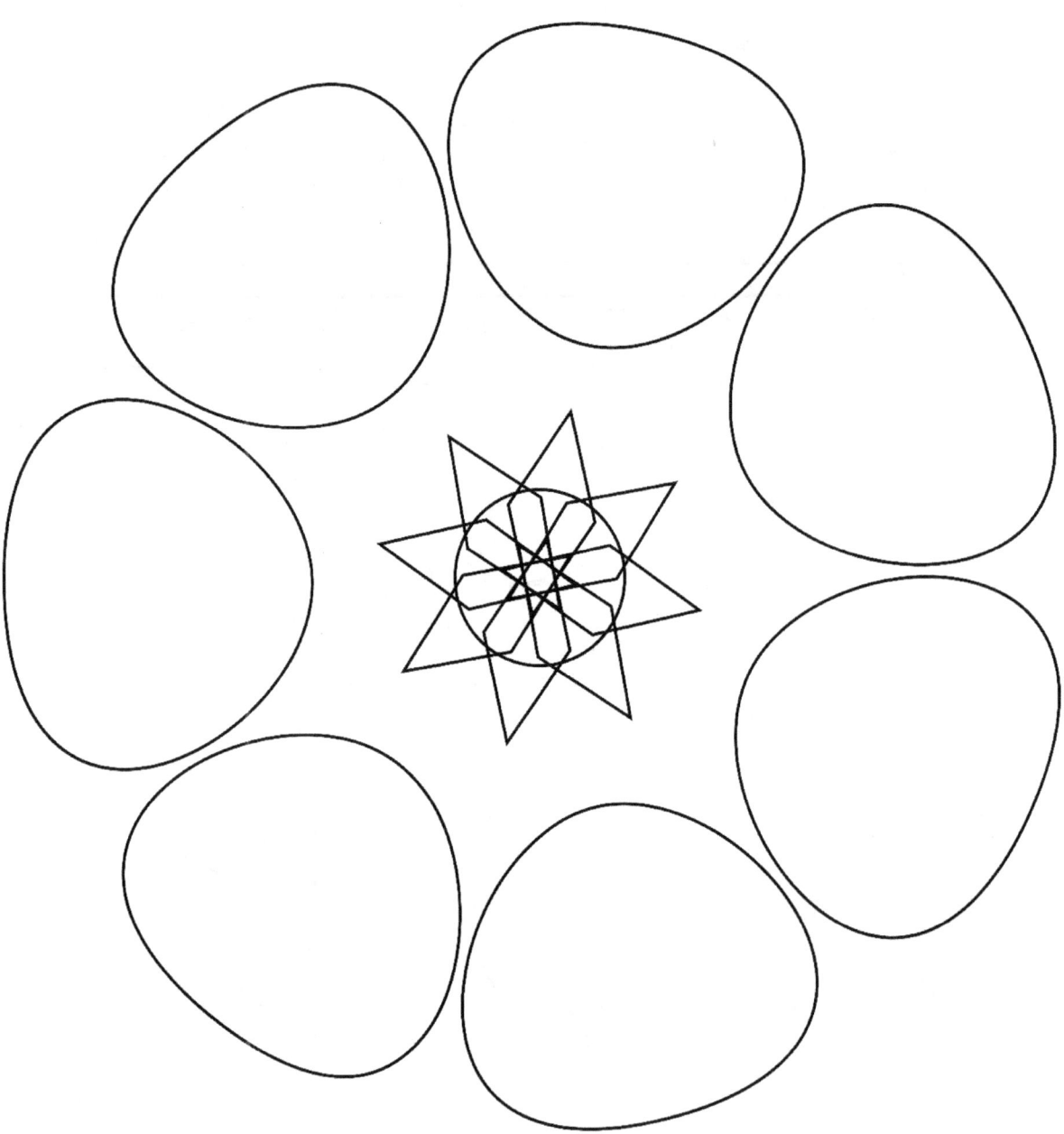

"We tend to think of meditation in only one way. But life itself is a meditation."

- Raul Julia

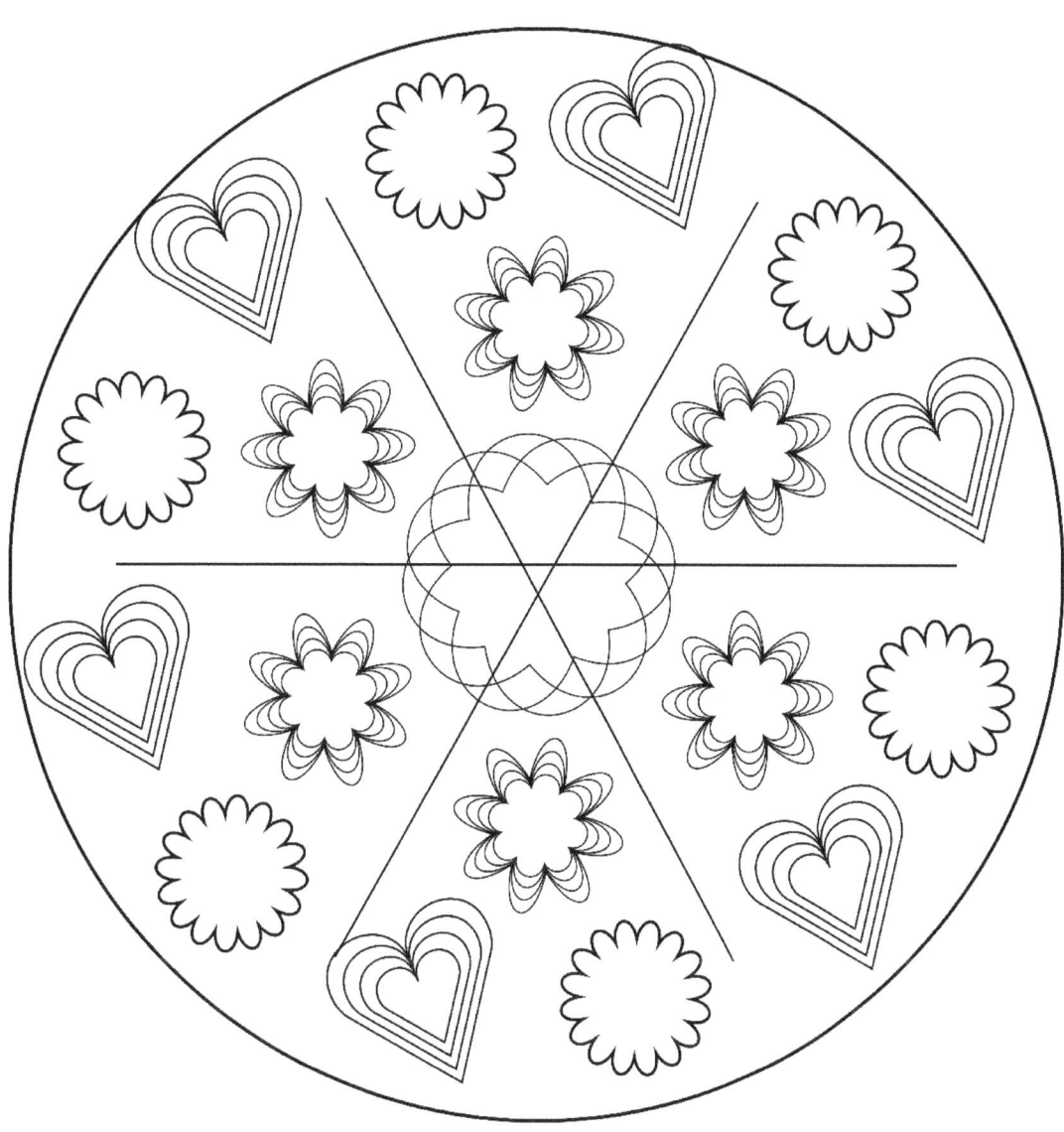

"Let no one come to you without leaving better and happier."

-Mother Theresa

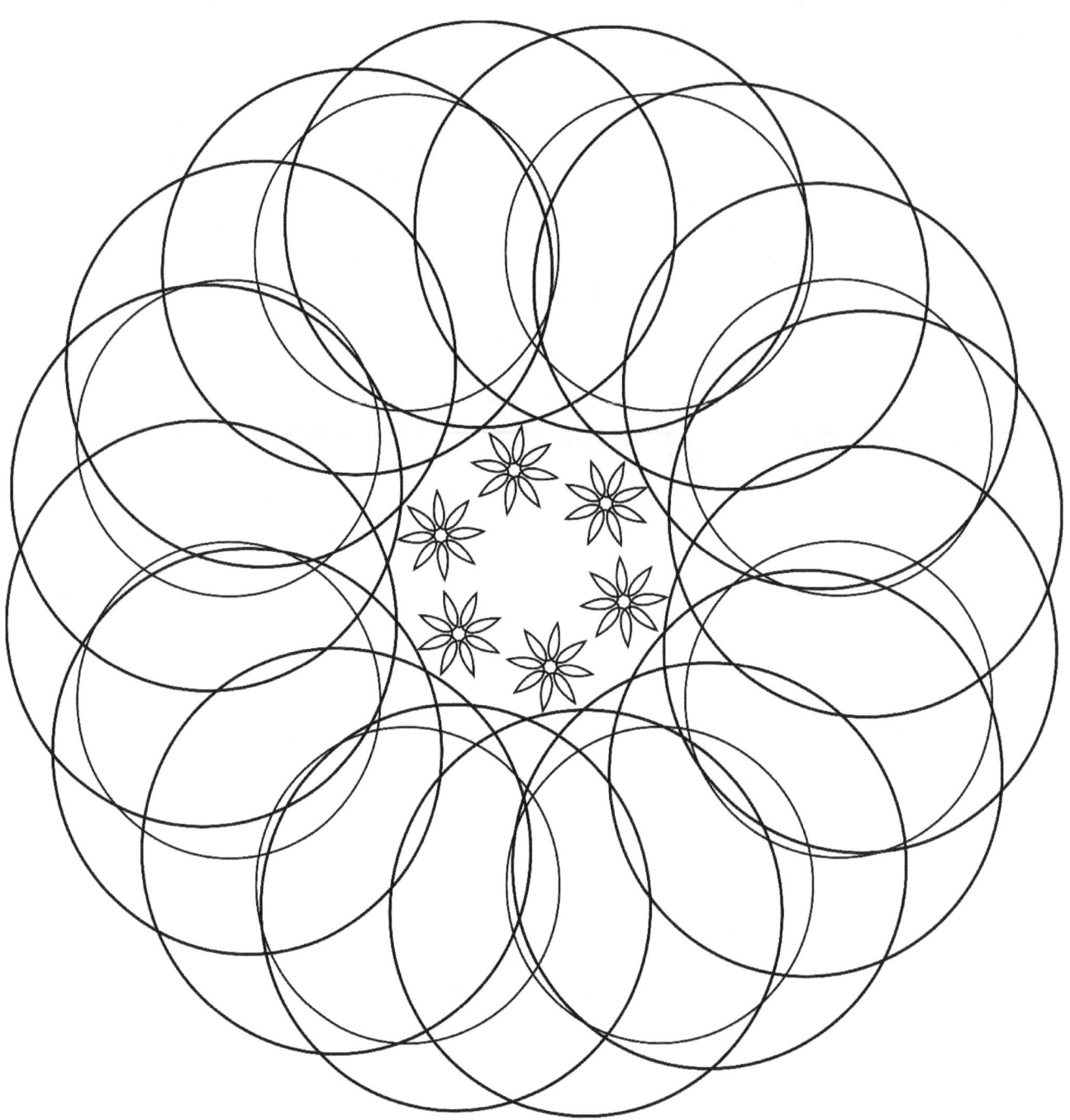

"Let me, O let me bathe my soul in colors, let me swallow the sunset, and drink the rainbow."
-Kahlil Gibran

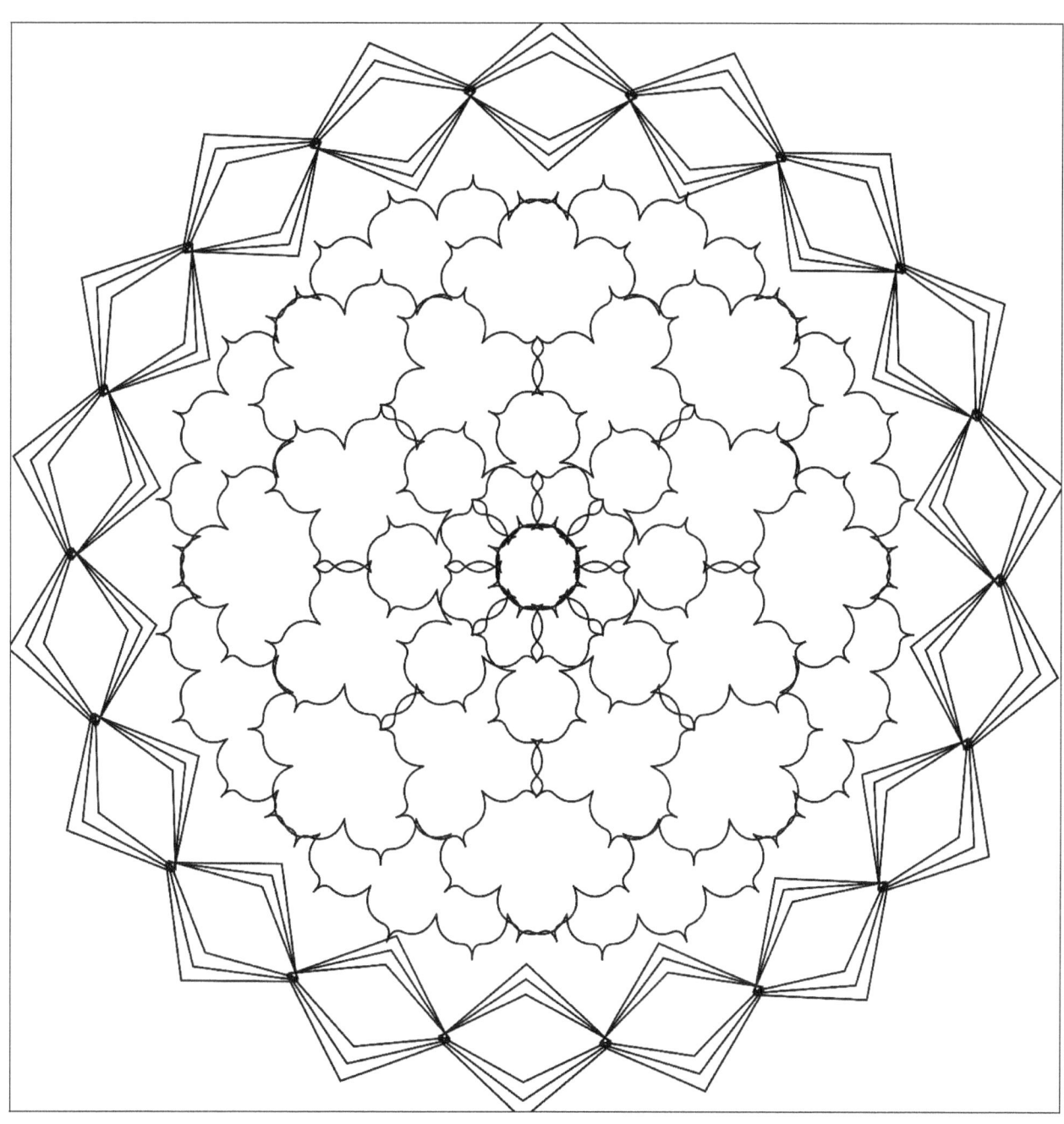

*"For every minute you remain angry, you give up sixty seconds of peace of mind."*

-Ralph Waldo Emerson

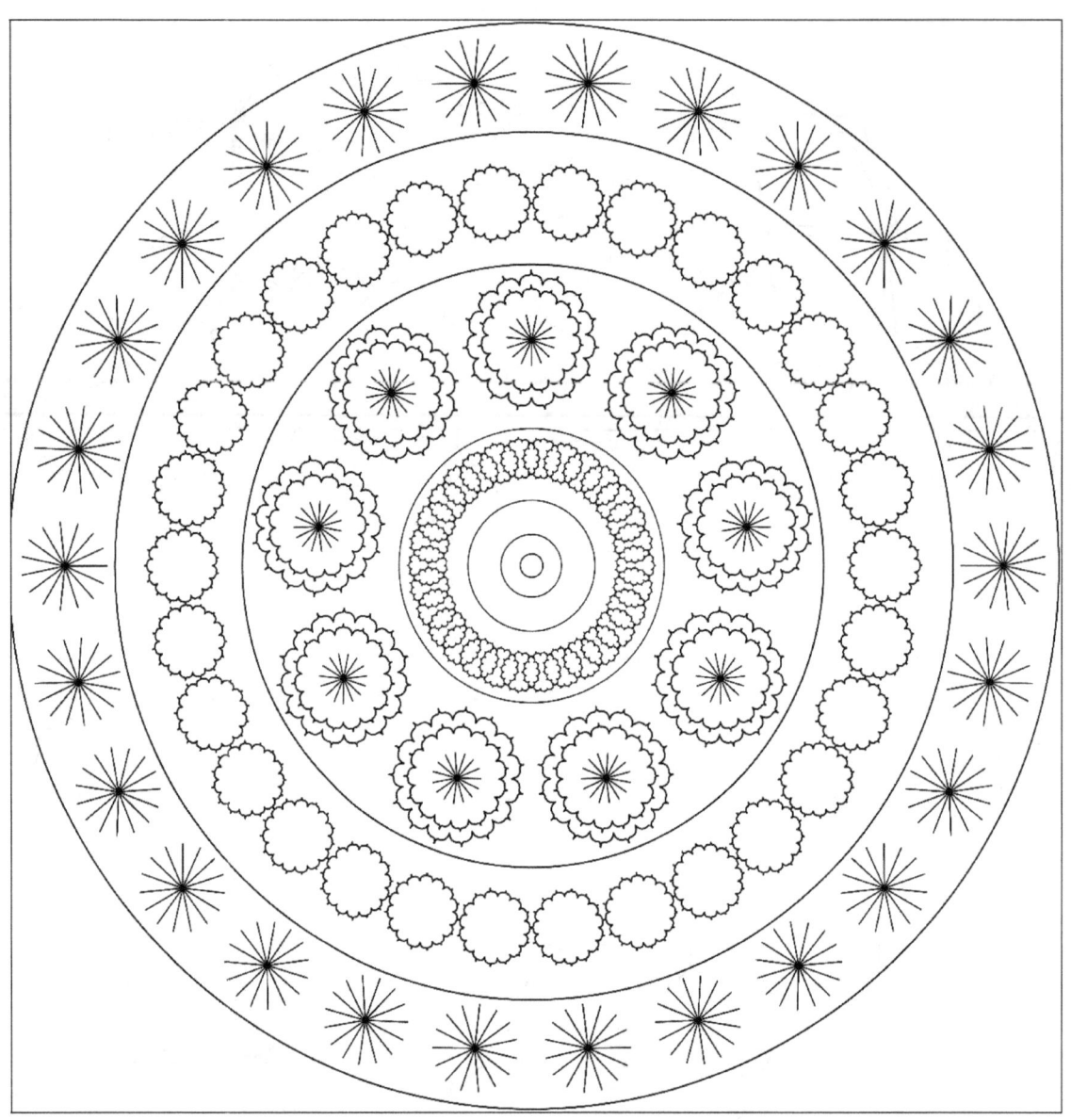

"Art opens the closets; airs out the cellars and attics. It brings healing."

-Julia Cameron

The Secret Life of Mandalas: A Coloring Book with Inspirational Poetry

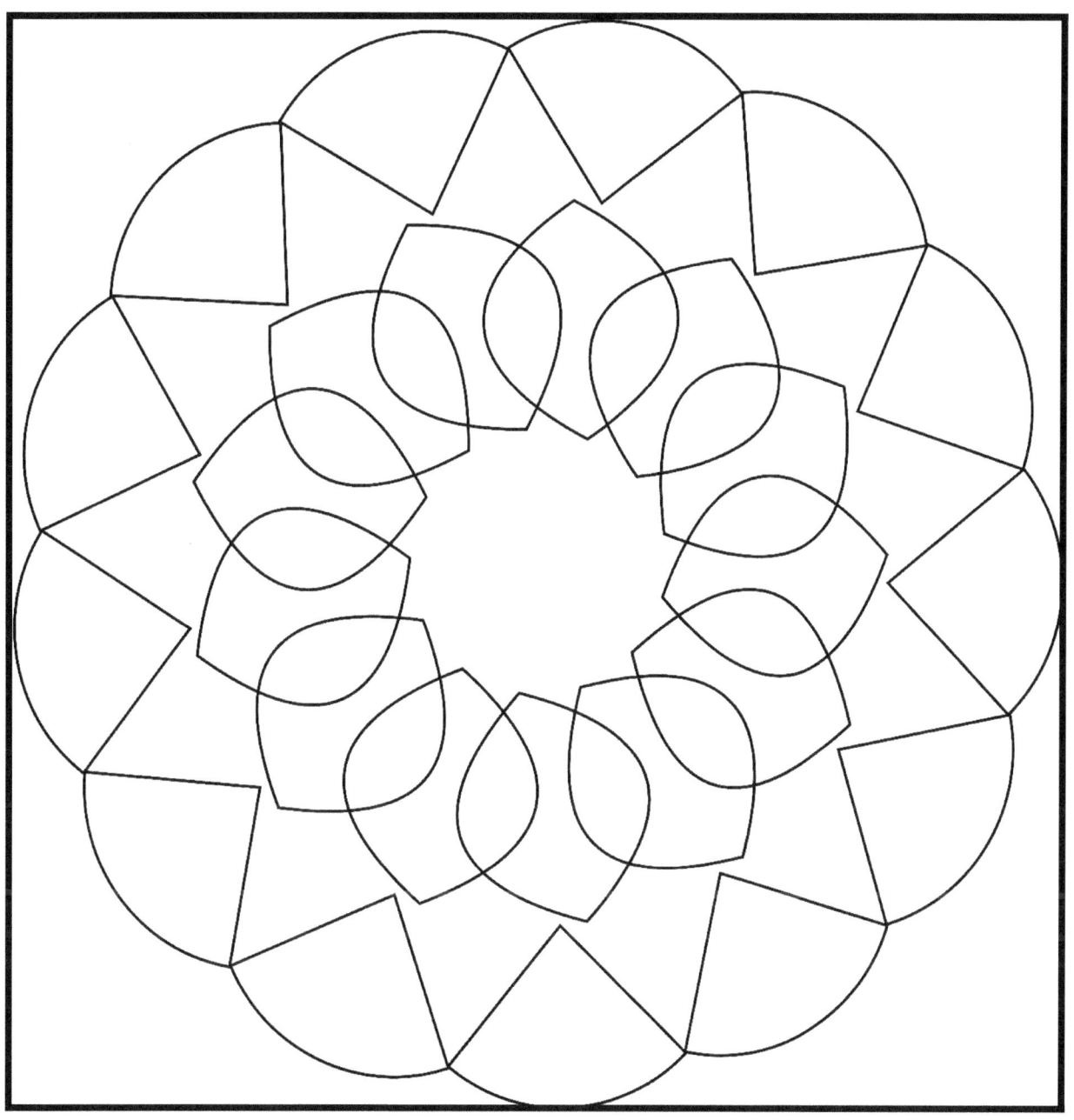

"Great art picks up where nature ends."

Marc Chagall

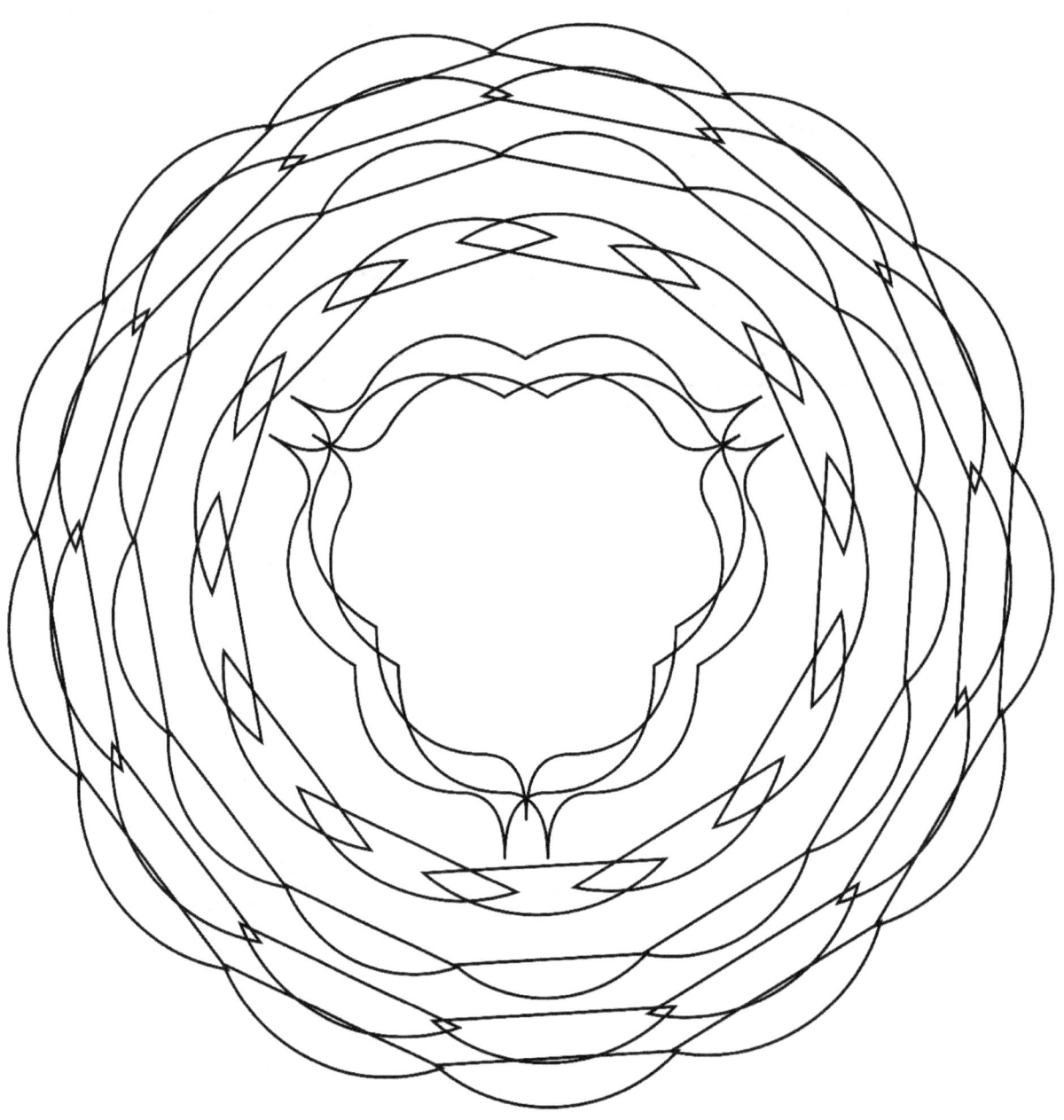

"You will see it when you believe it."
-Dr. Wayne Dyer

The Secret Life of Mandalas: A Coloring Book with Inspirational Poetry

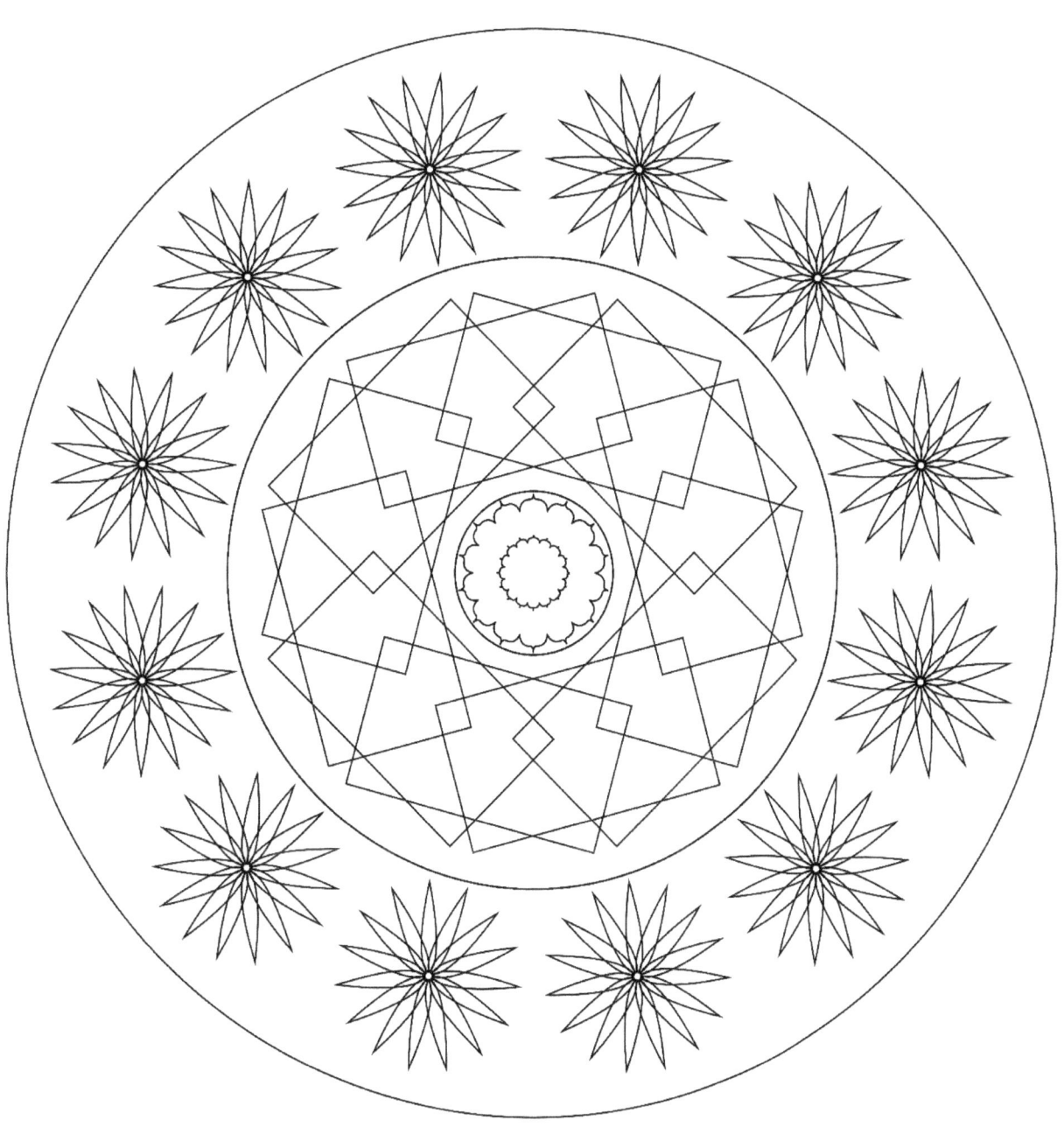

"I found I could say things with color and shapes that I couldn't say any other way--things I had no words for."

Georgia O'Keefe

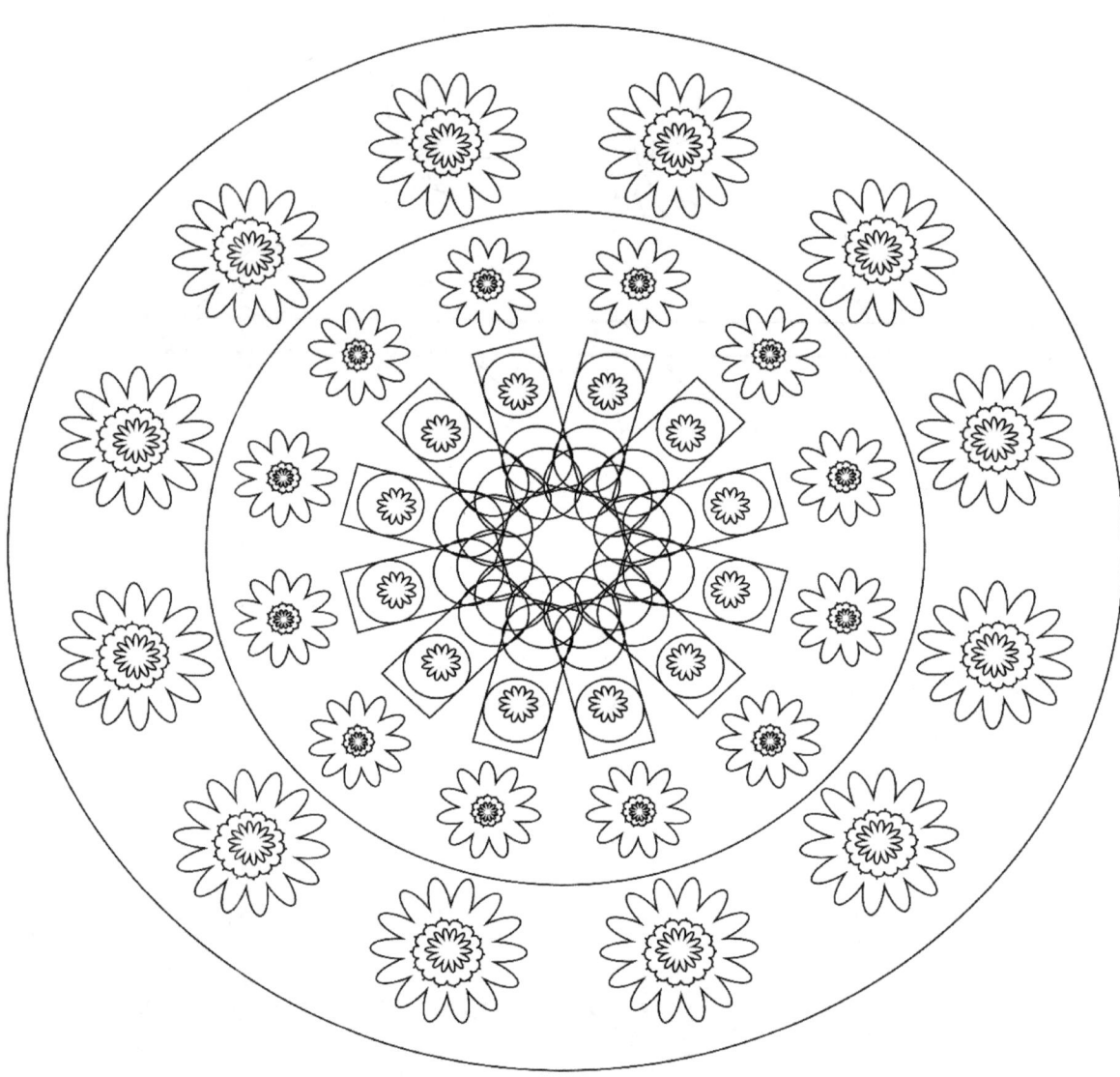

"One touch of nature makes the whole world kin."
-William Shakespeare

The Secret Life of Mandalas: A Coloring Book with Inspirational Poetry

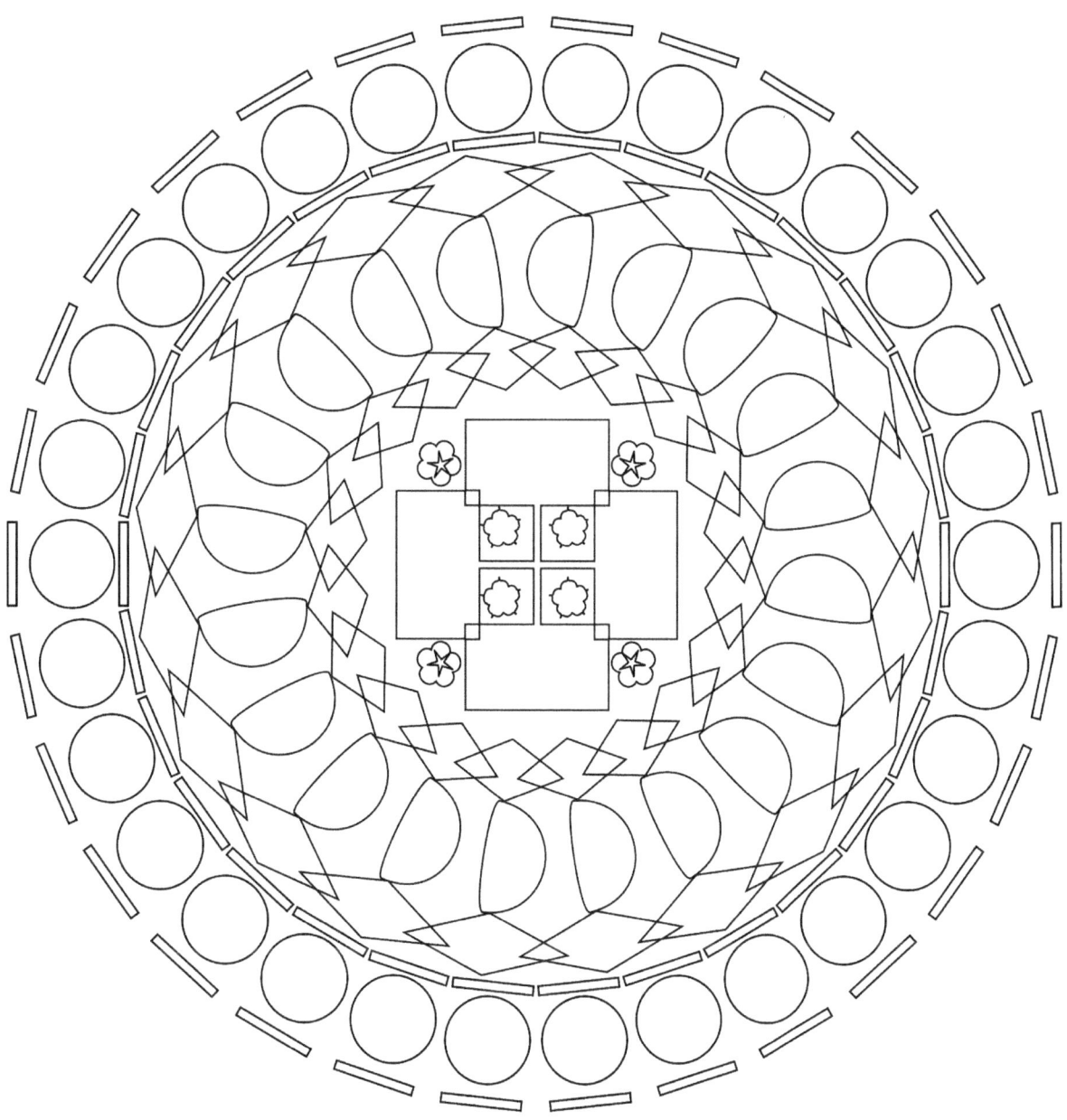

"Real shapes and real patterns are things you would observe in nature, like the marks on the back of a cobra's hood or the markings on a fish or a lizard. Imaginary shapes are just that, symbols that come to a person in dreams or reveries and are charged with meaning."
- *Jim Woodring*

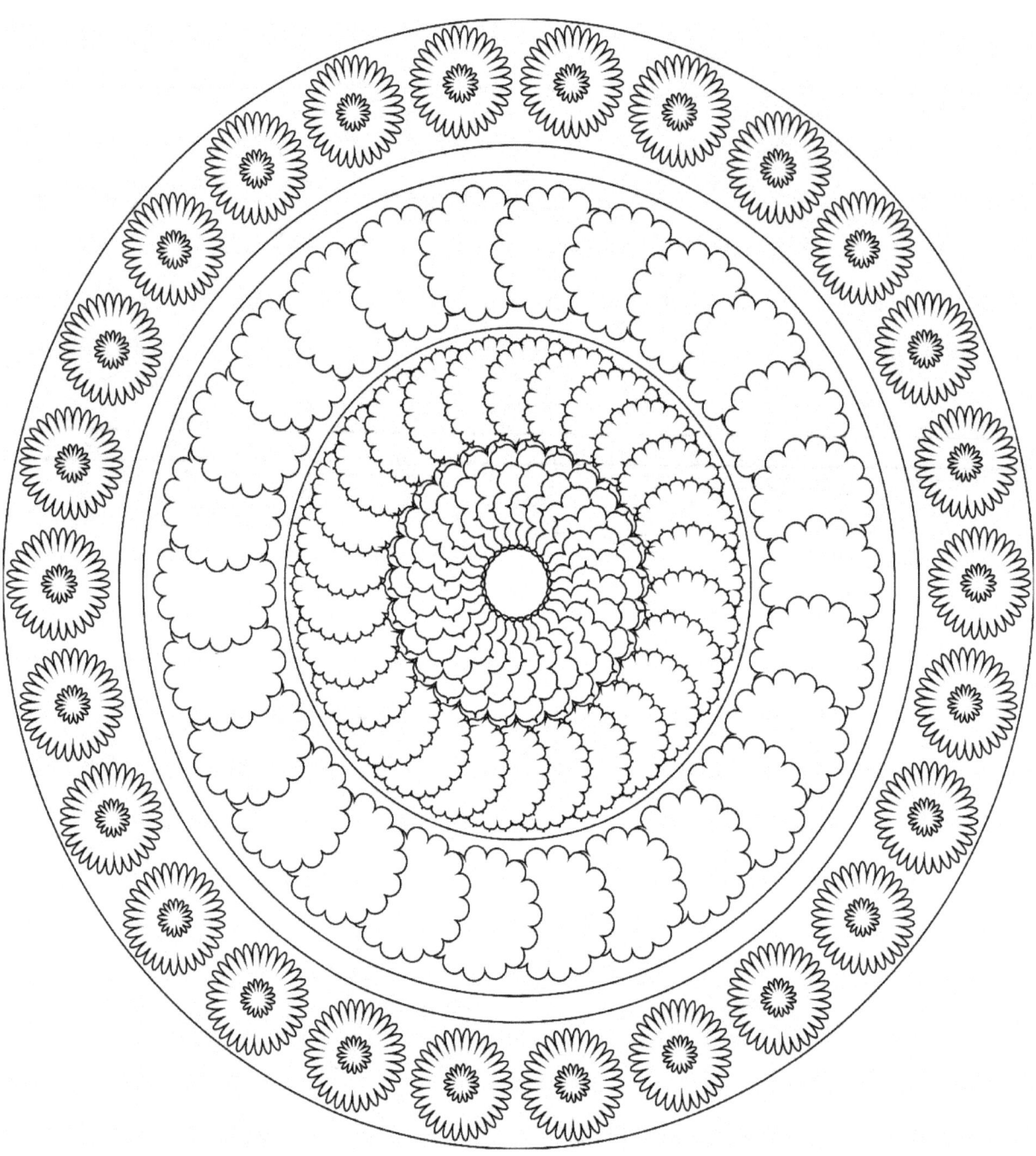

"Nature does not hurry, yet everything is accomplished."

Lao Tzu

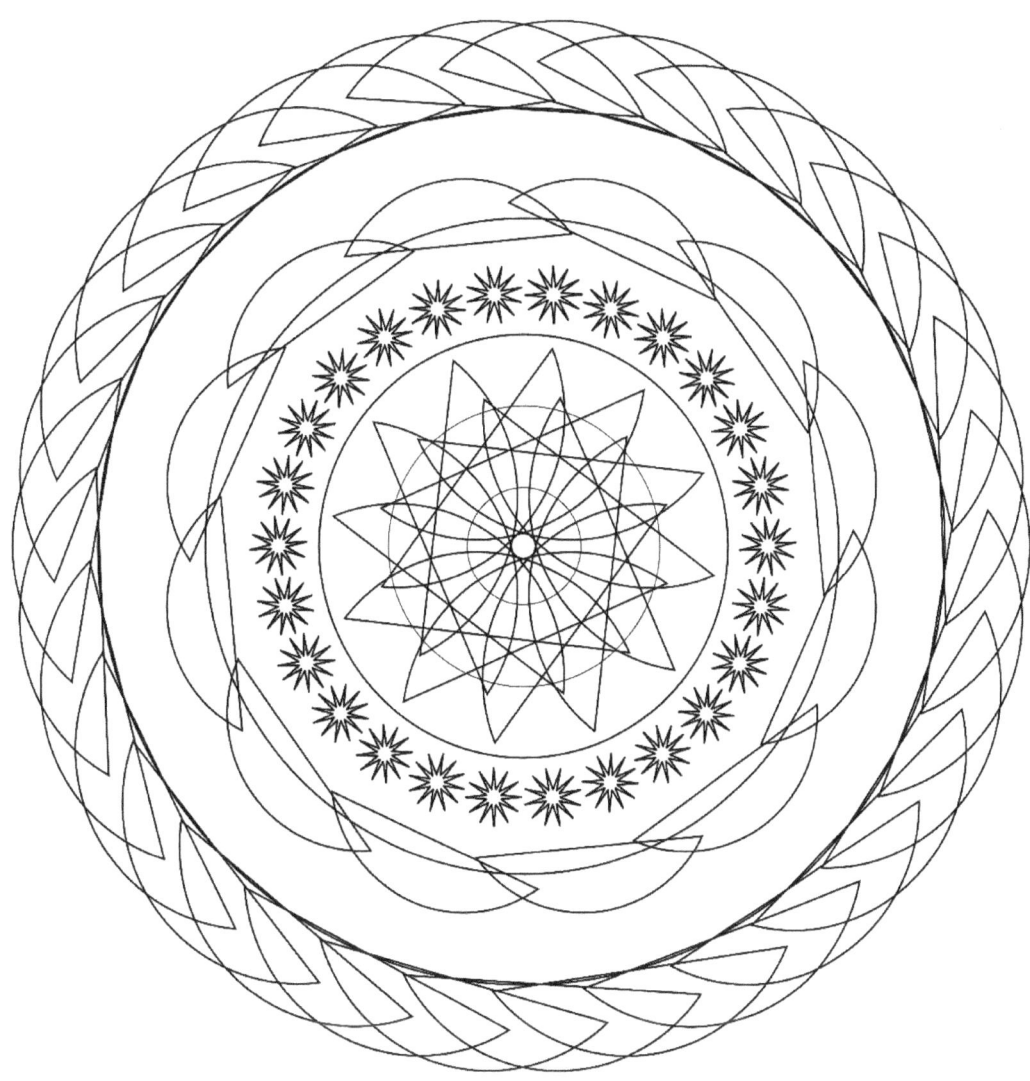

"One of the most tragic things I know about human nature is that all of us tend to put off living. We are all dreaming of some magical rose garden over the horizon-instead of enjoying the roses blooming outside our windows today"

*-Dale Carnegie*

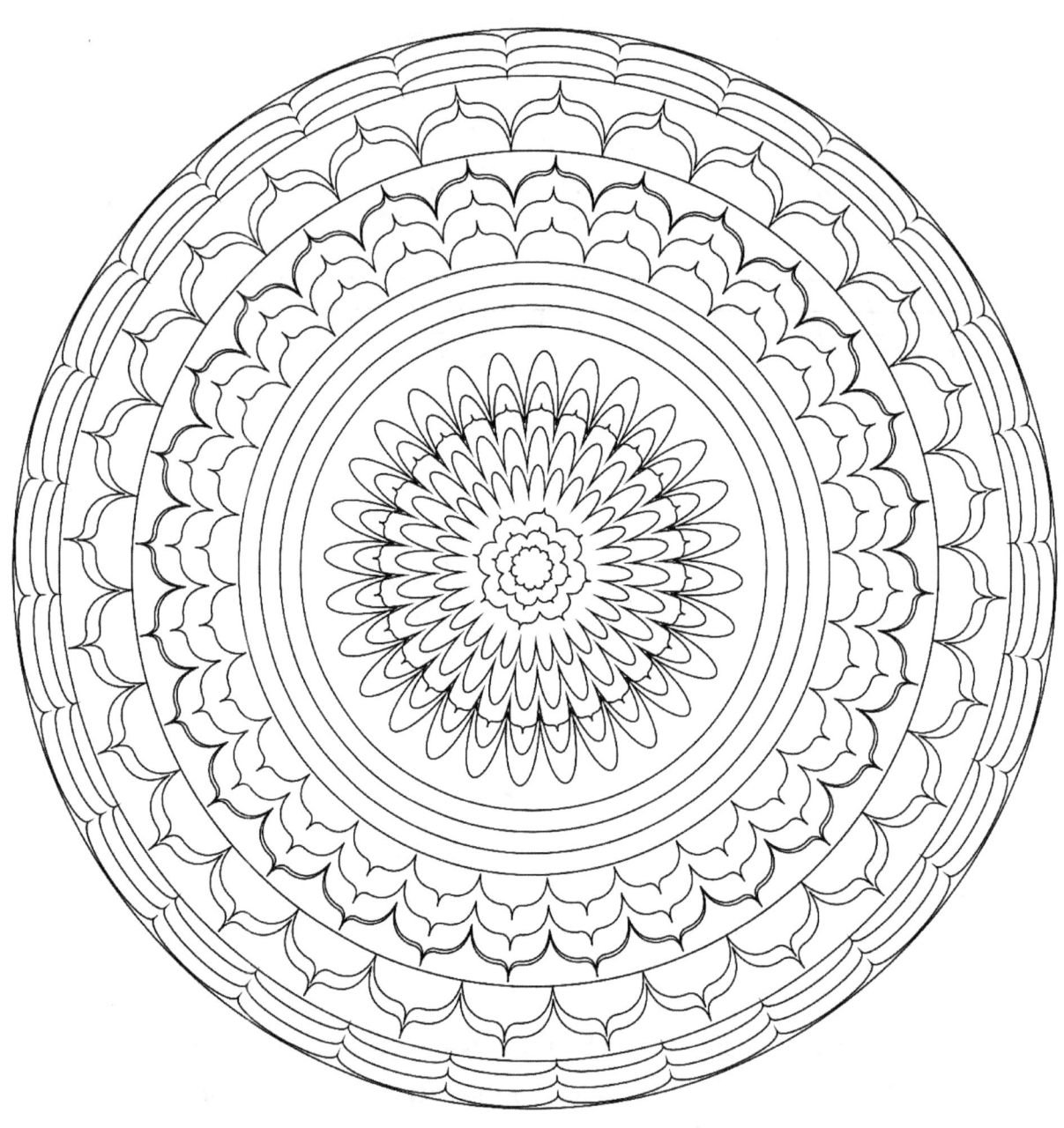

"Creativity is contagious – Pass it on."
Albert Einstein

"When we try to pick out anything by itself, we find it hitched to everything else in the Universe."

-John Muir

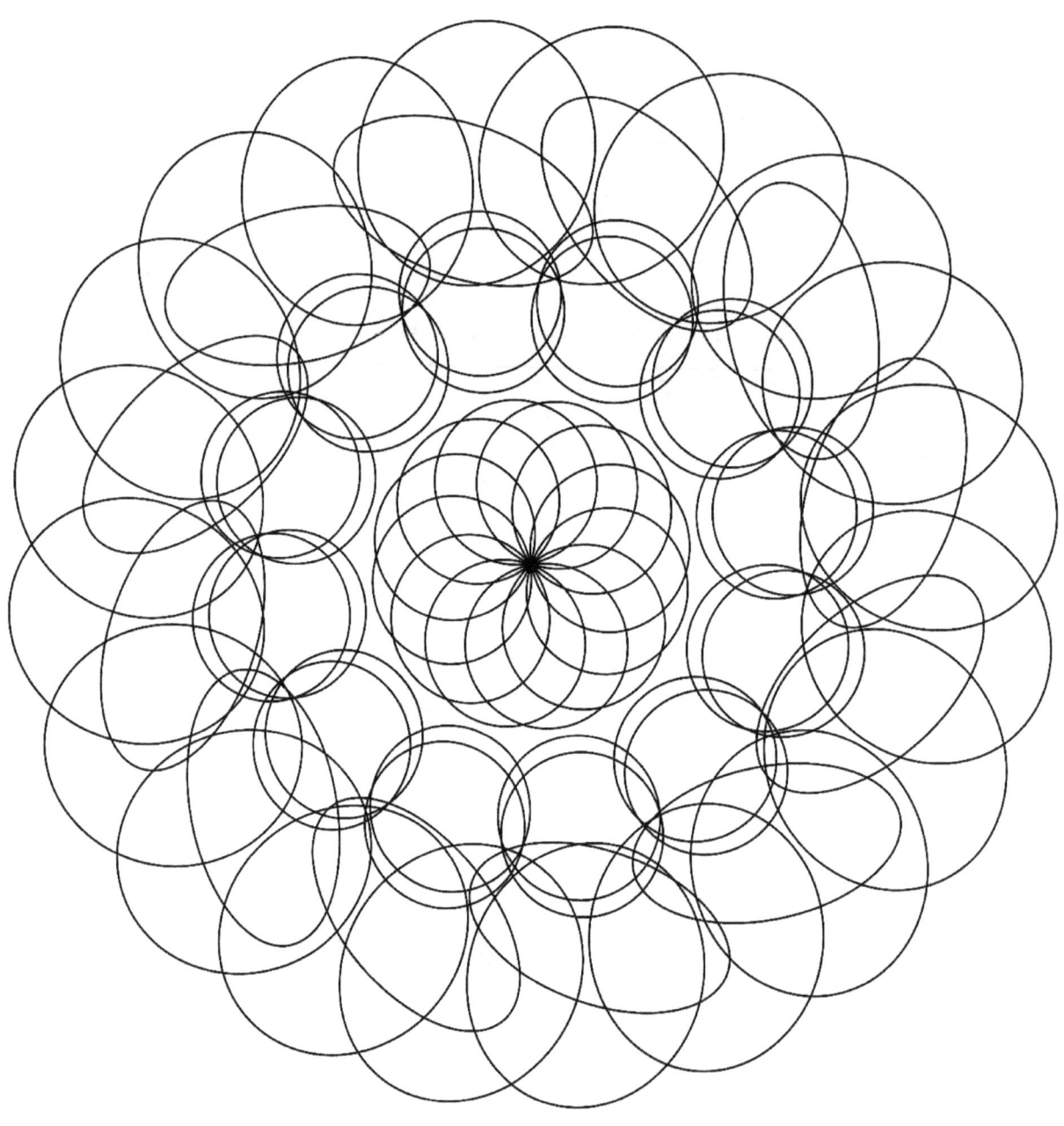

"Anyone who says you can't see a thought simply doesn't know art."

-Wynetka Ann Reynolds

"What art offers is space — a certain breathing room for the spirit."

- John Updike

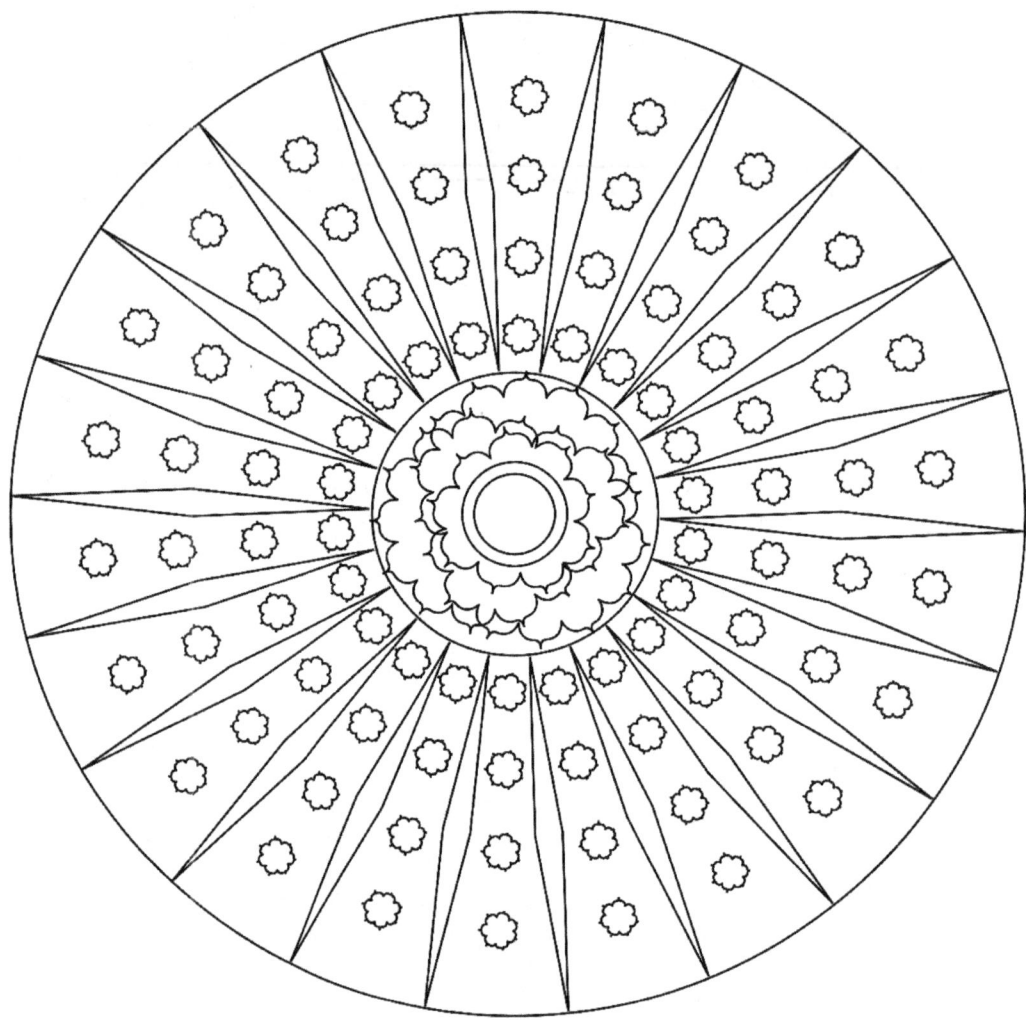

"God is the friend of silence. Trees, flowers, grass grow in silence. See the stars, moons and sun, how they move in silence."

-Mother Theresa

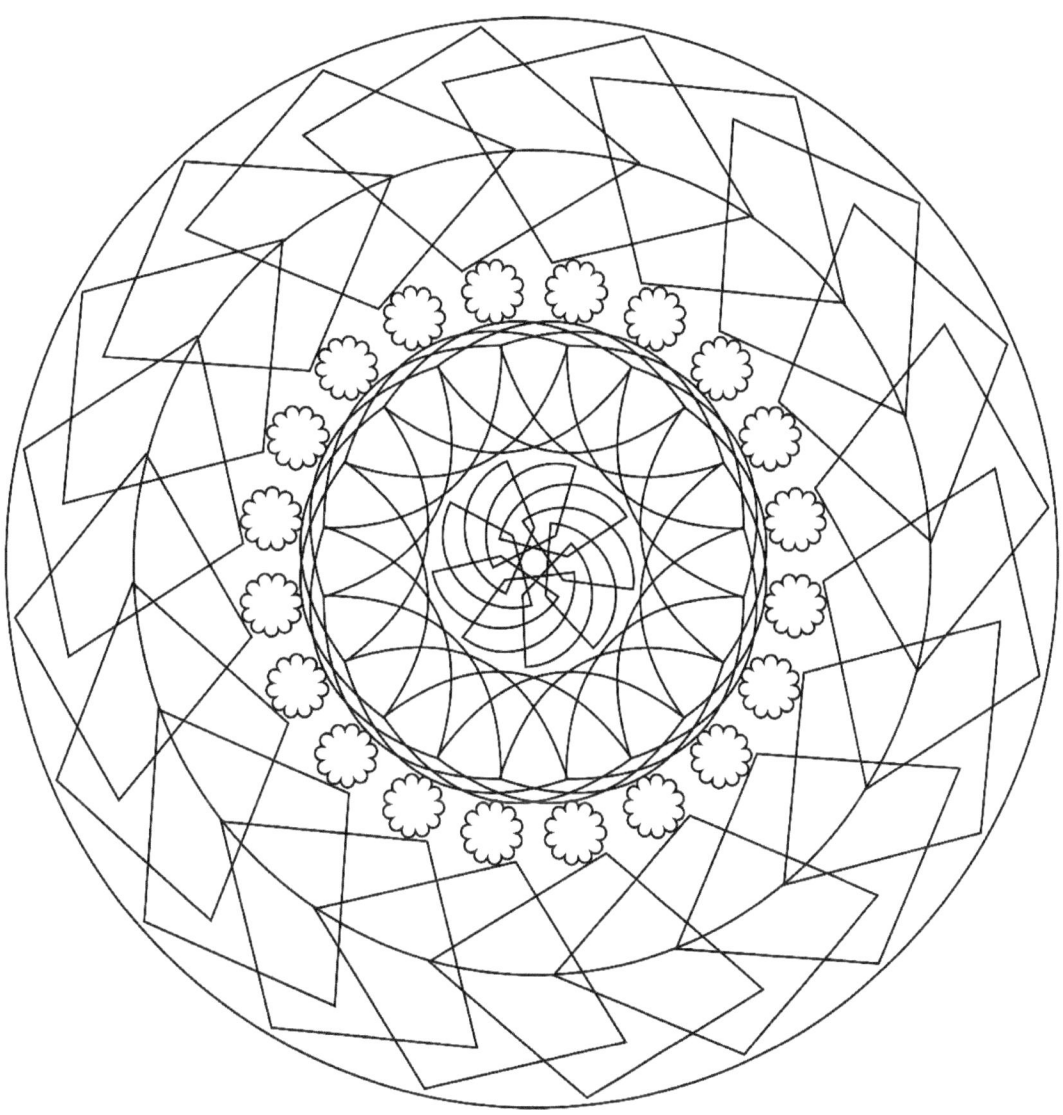

"It is not your paintings I like, It is your painting."

-Albert Camus

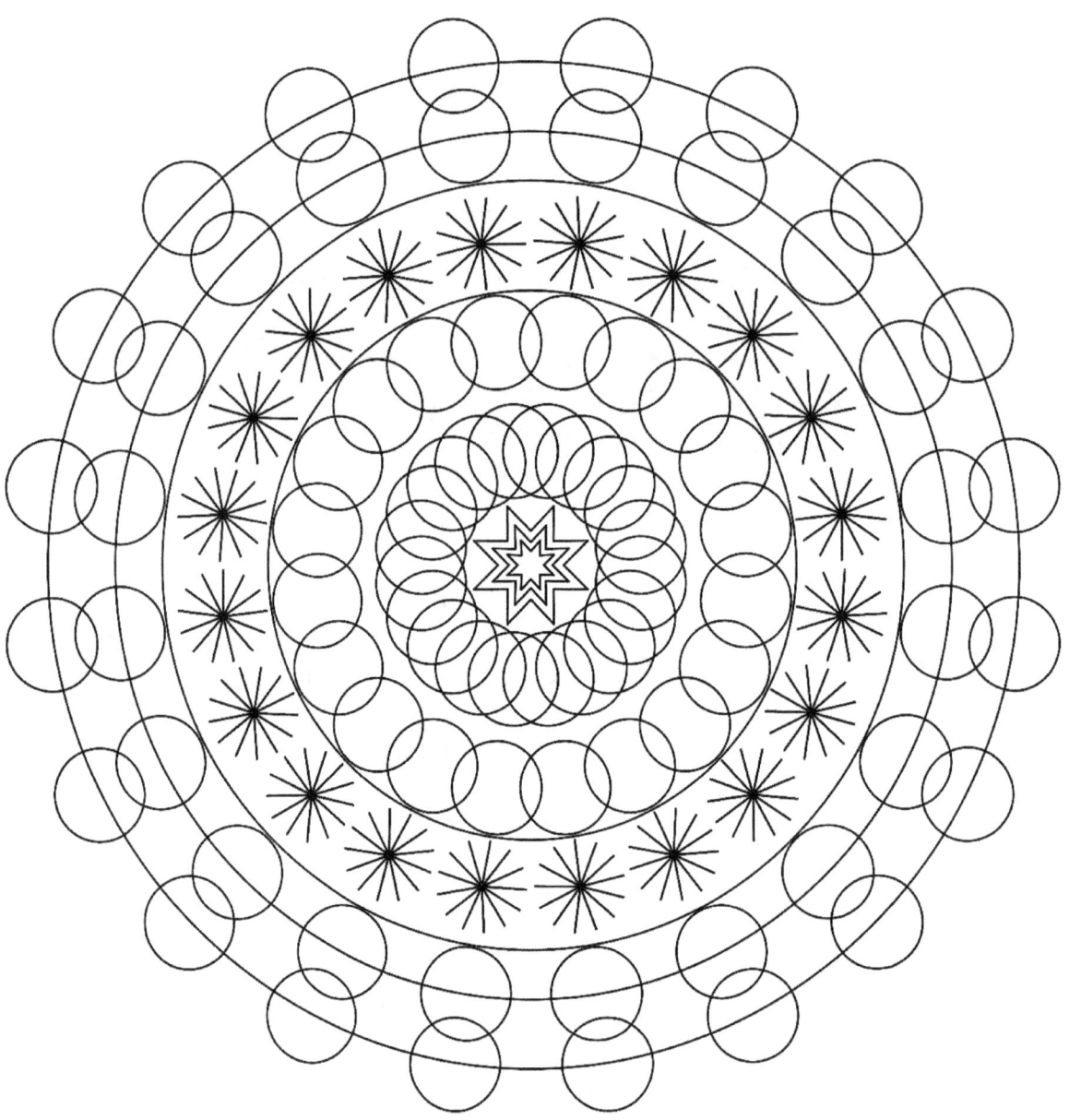

"The flower's perfume has no form, but it pervades space. Likewise, through a spiral of mandalas formless reality is known."

- Saraha

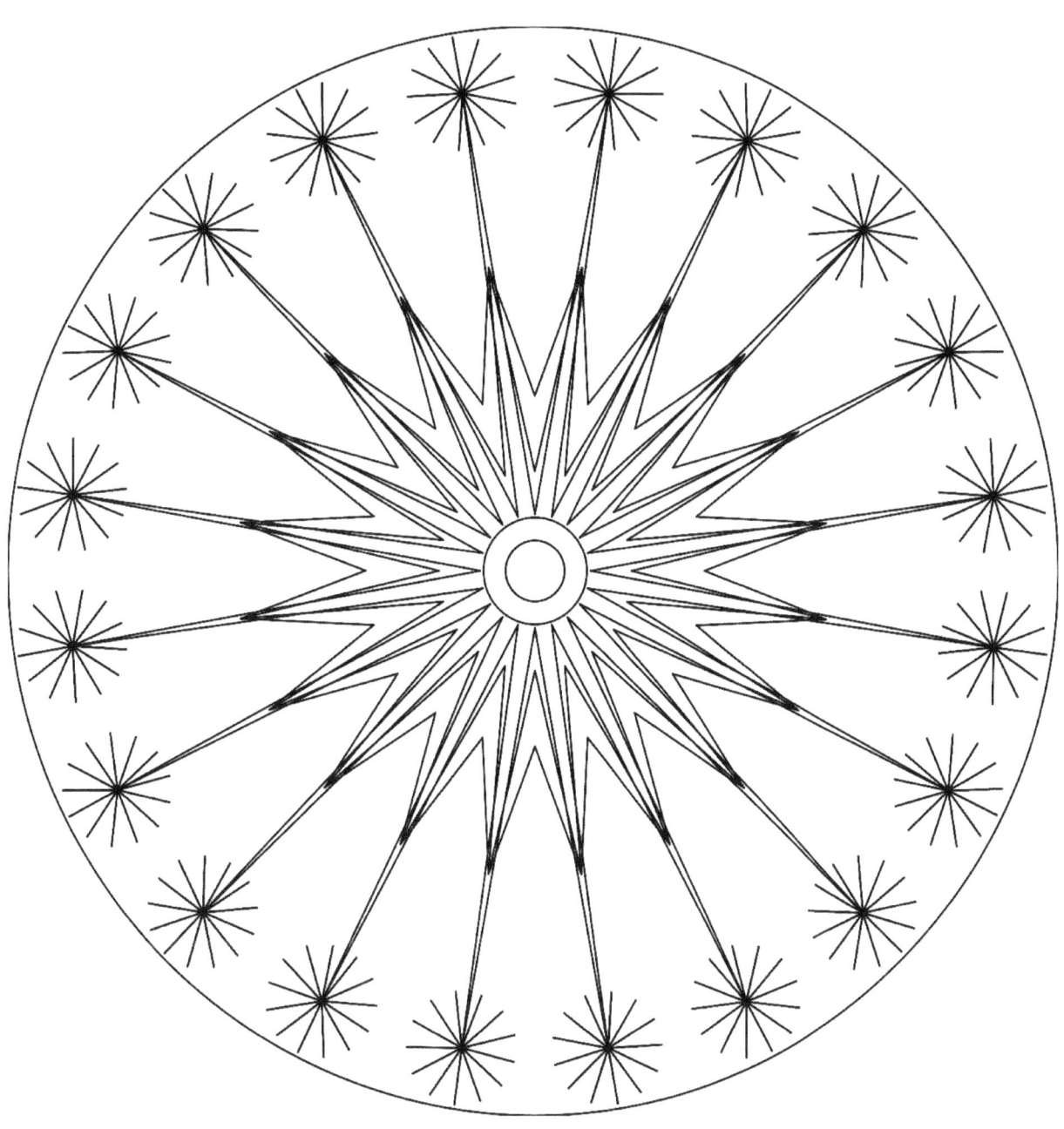

"I dream my painting and I paint my dream."
— Vincent van Gogh

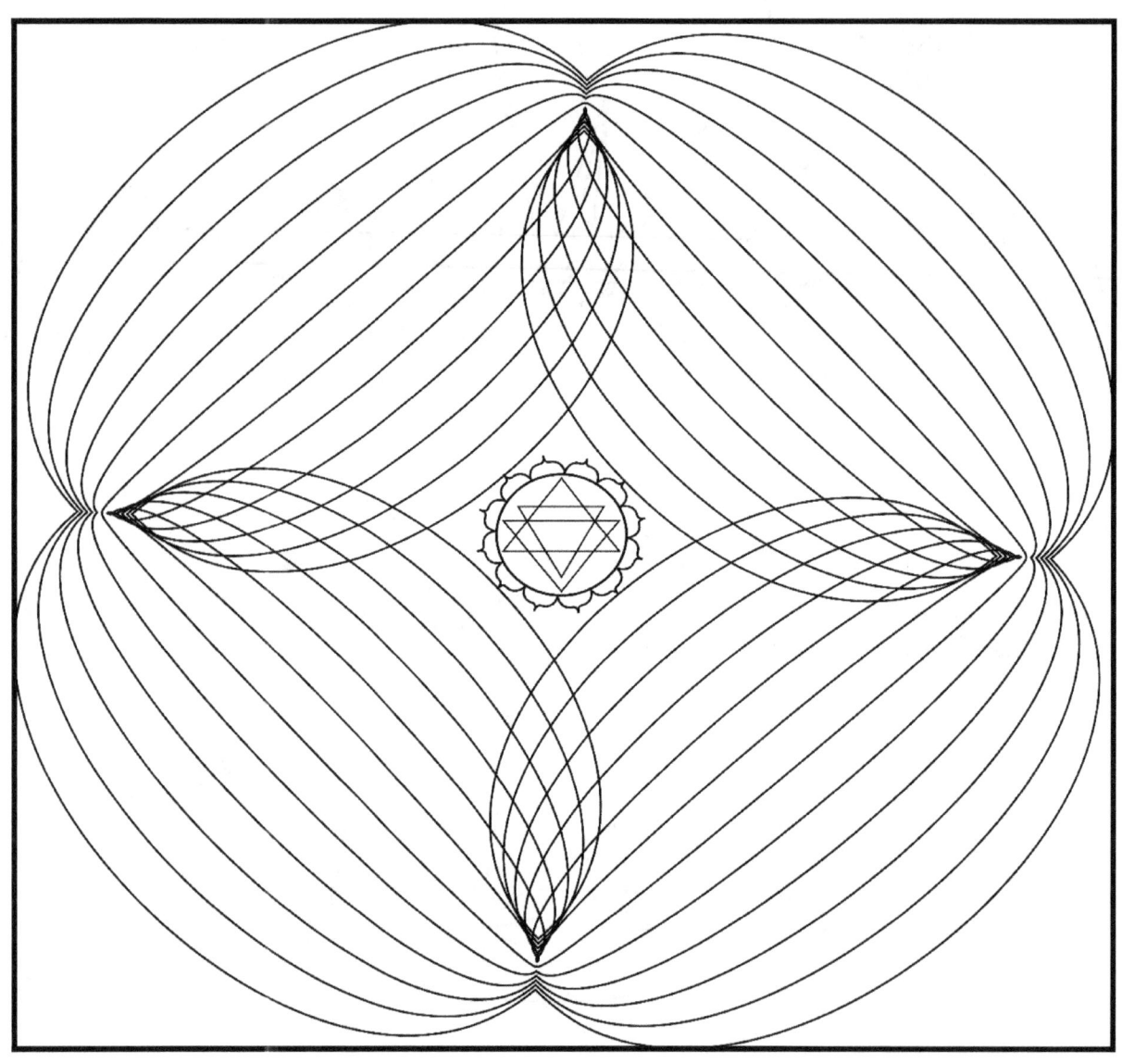

"When I know your soul, I will paint your eyes"
-Amedeo Modigliani

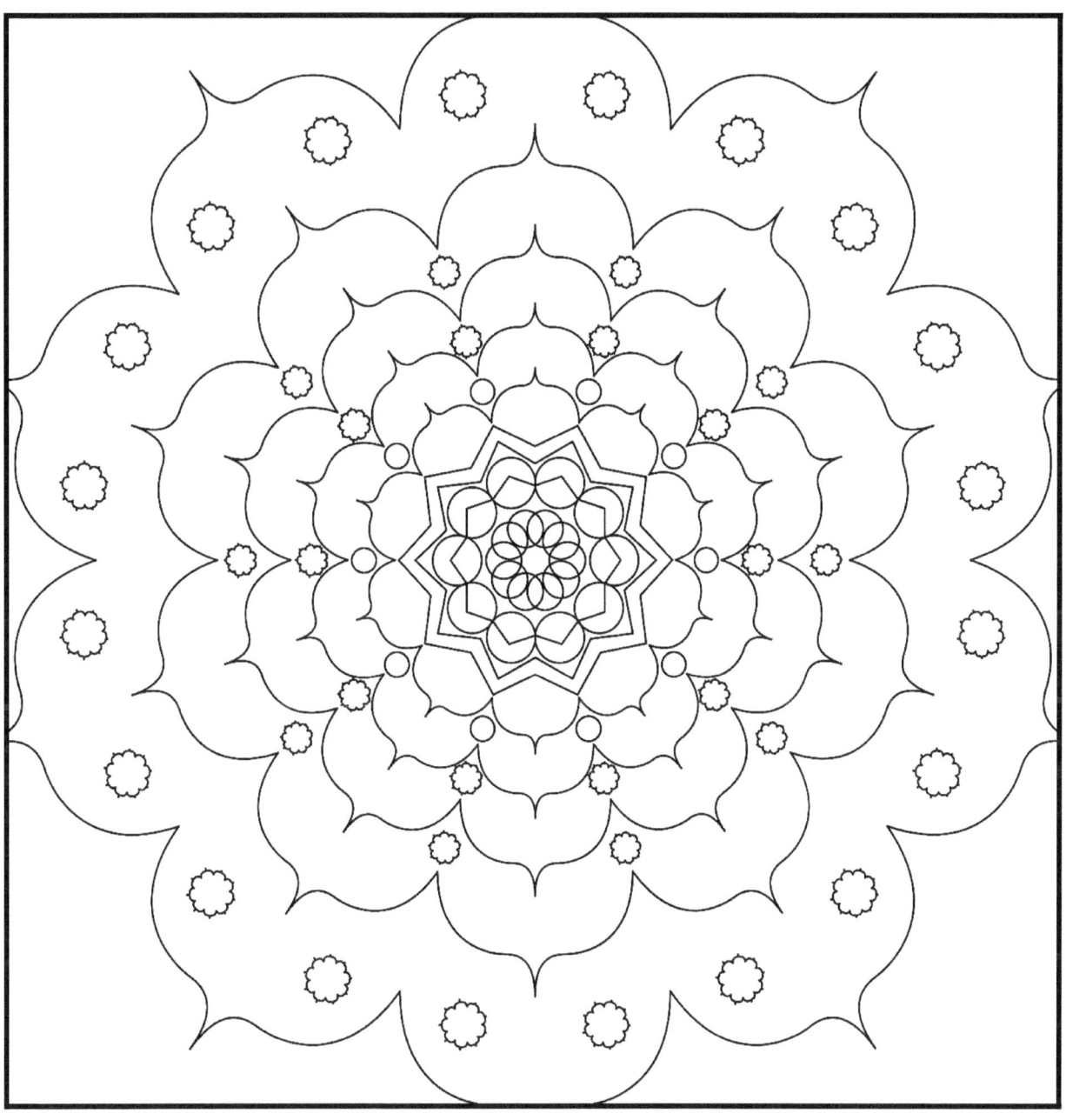

"If I did not start painting, I would have raised chickens."

- Grandma Moses

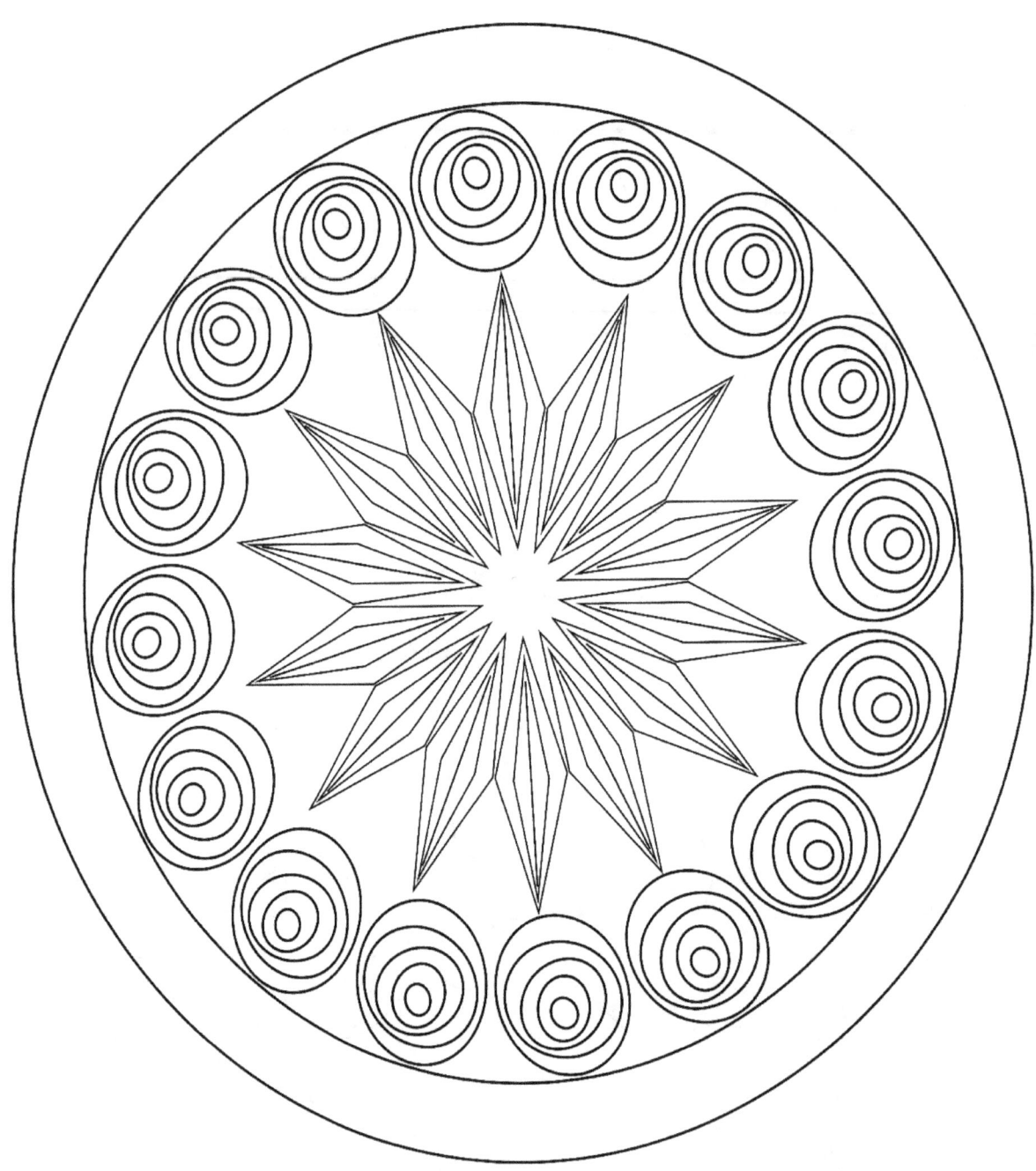

"Painting is poetry that is seen rather than felt,

and poetry is painting that is felt rather than seen."

– Leonardo da Vinci

"A painting was a translation of the language of my heart."
-Amy Tan

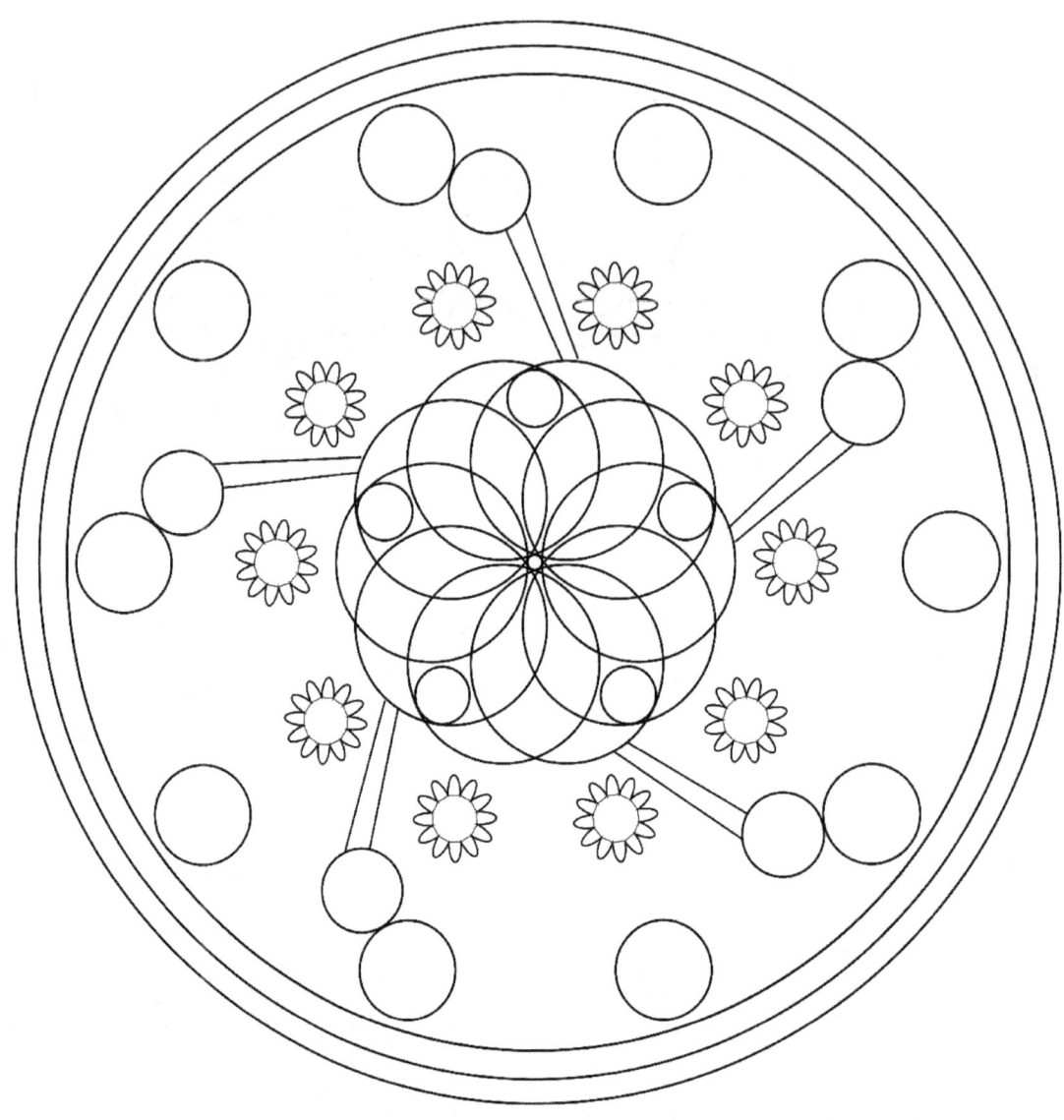

"If you could say it in words, there would be no reason to paint."
-Edward Hopper

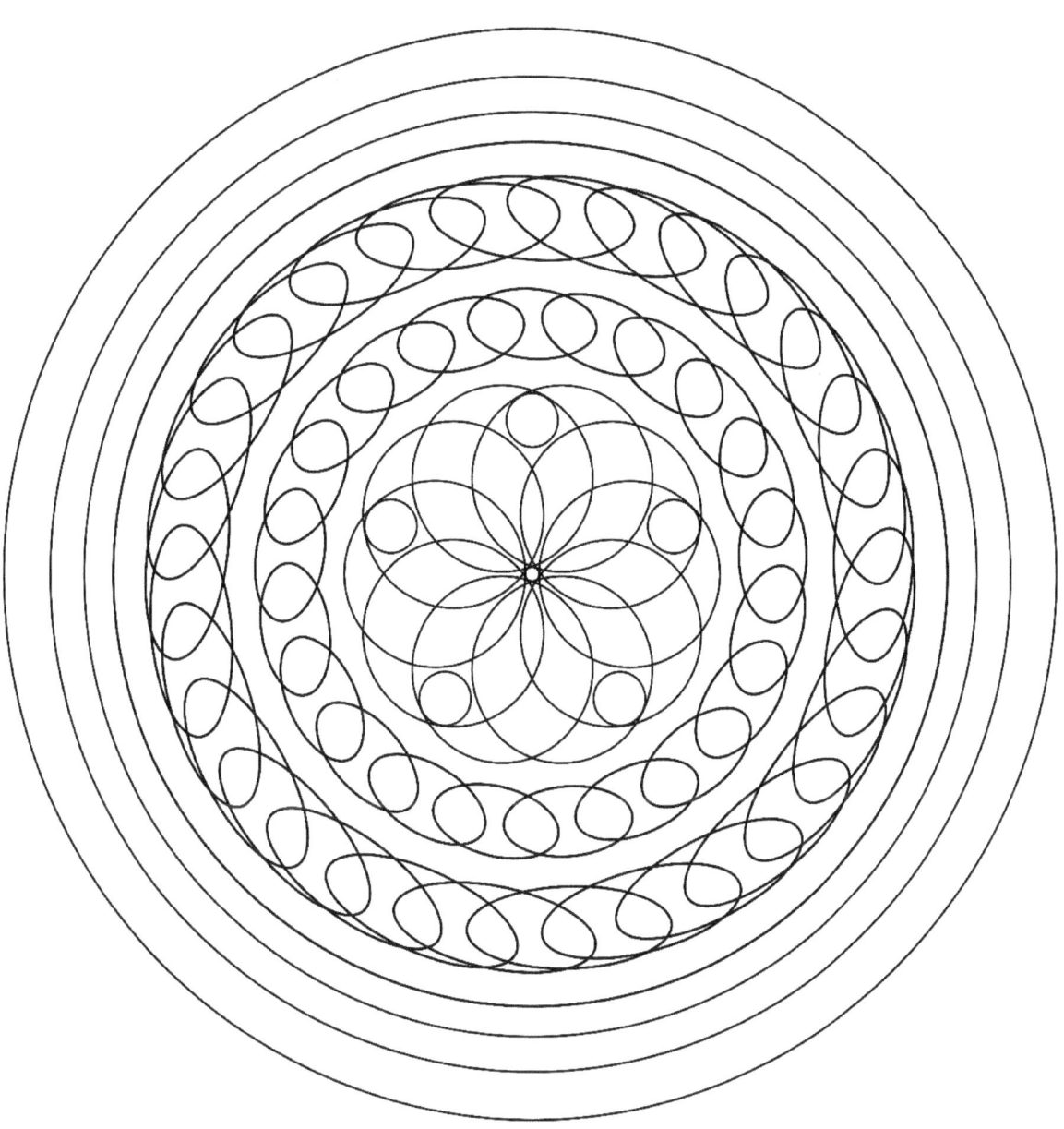

"Sin arte, la crudeza de la realidad haría del mundo insoportable."
-George Bernard Shaw.

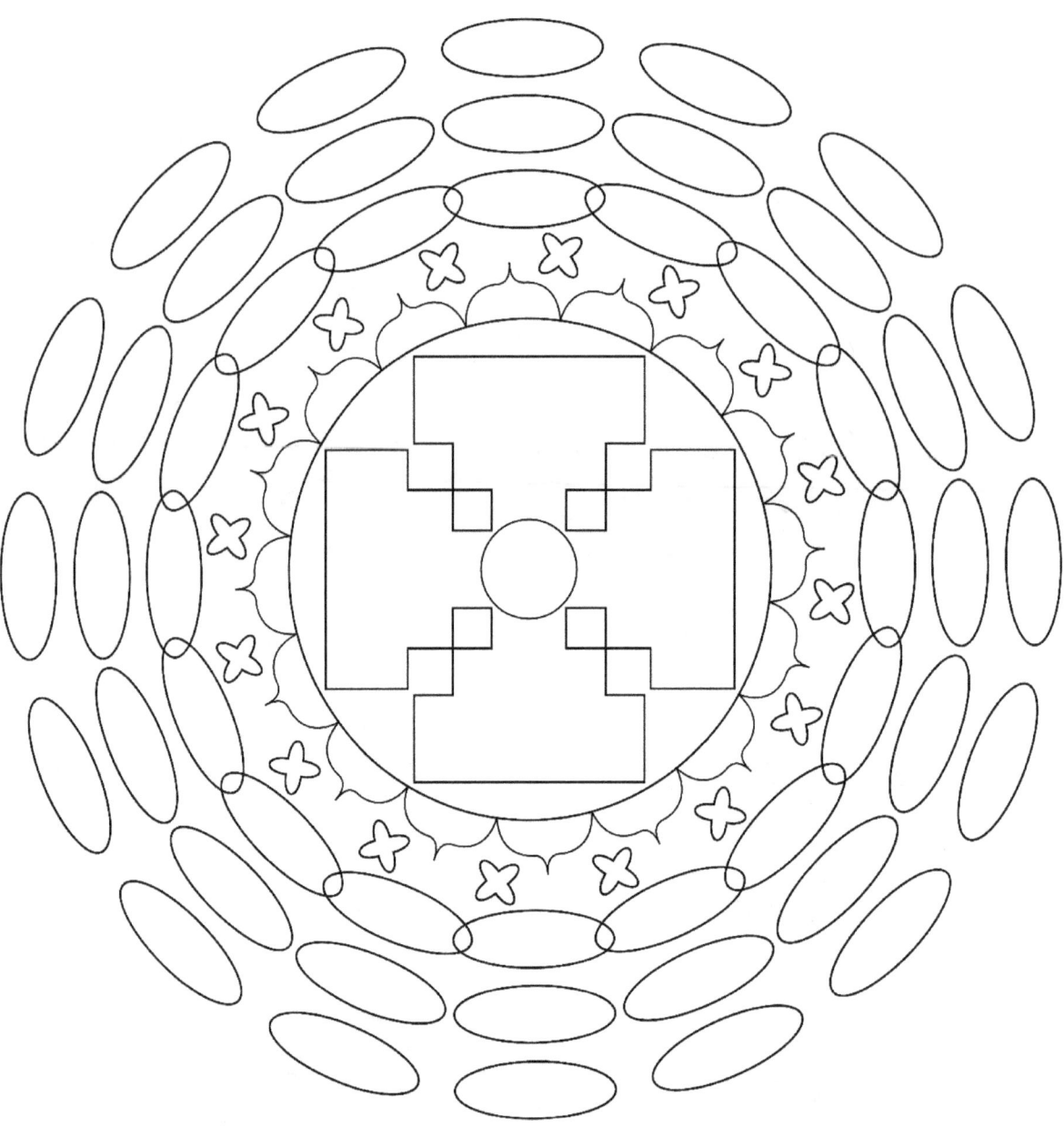

"Painting is a grandchild of nature. It is related to God."

-Rembrandt

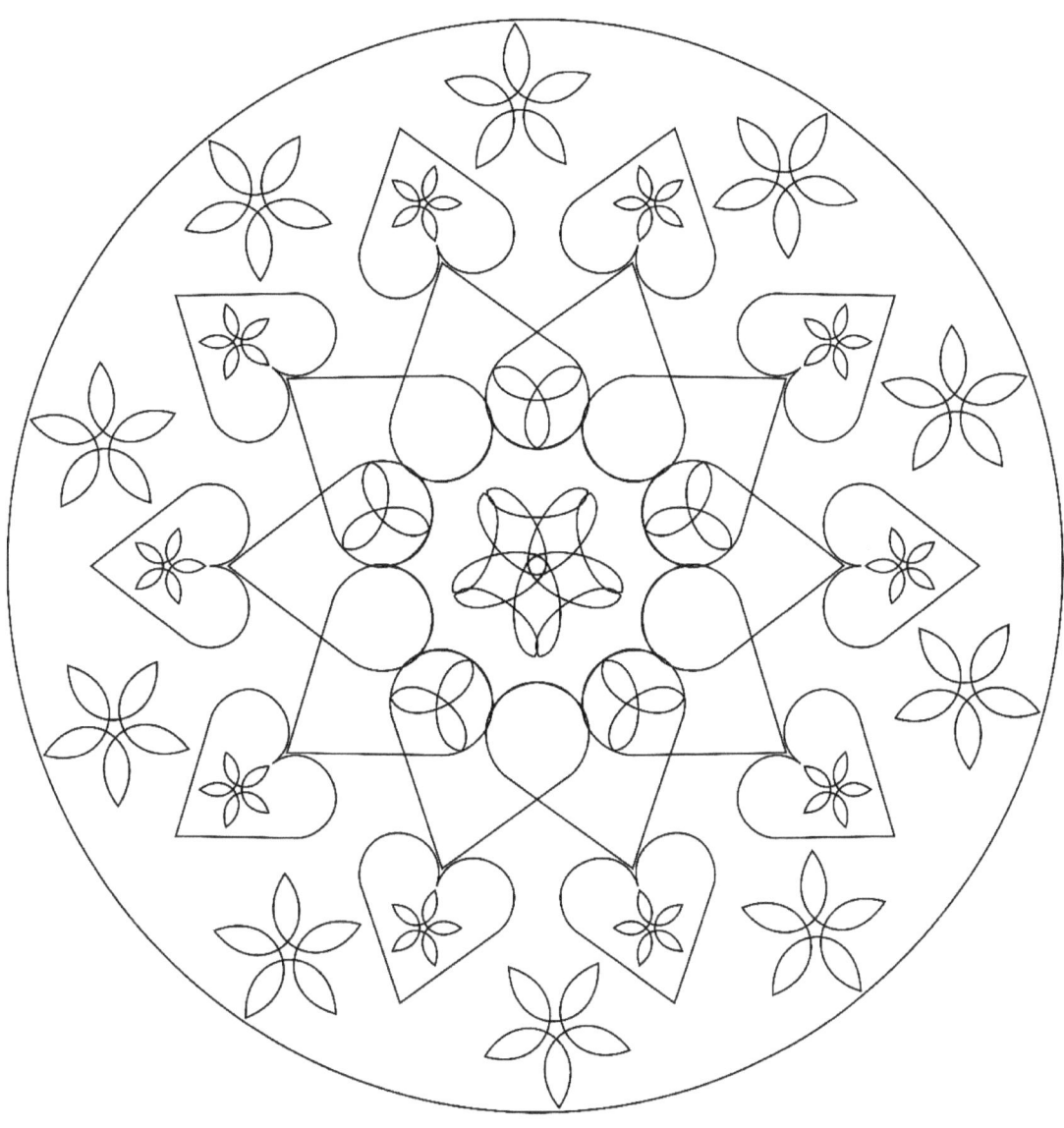

"I feel that there is nothing more truly artistic than to love people."

- Vincent Van Gogh

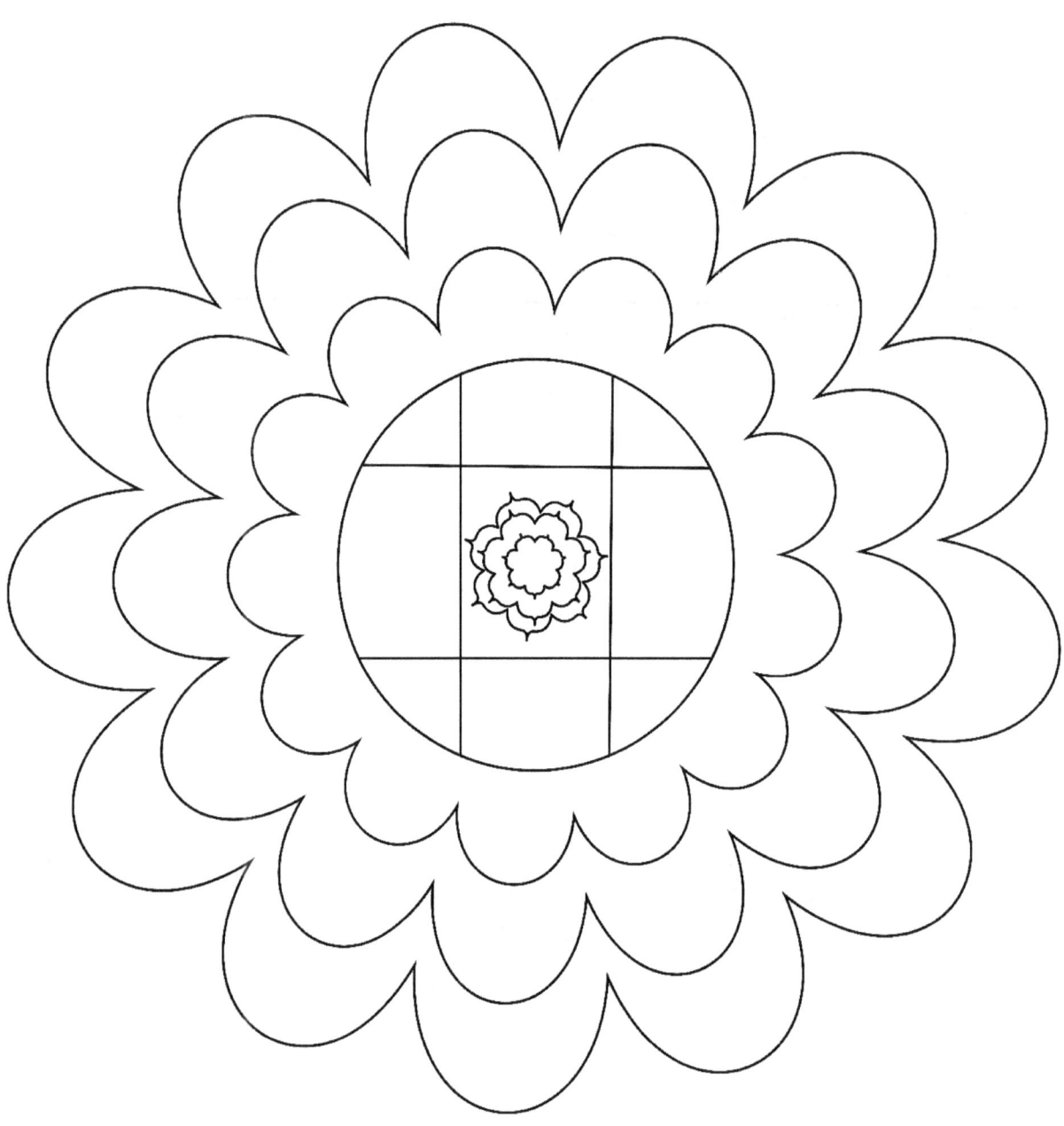

"Painting is a great outlet for those inner emotions you cannot get out any other way."
-Carol Brearley

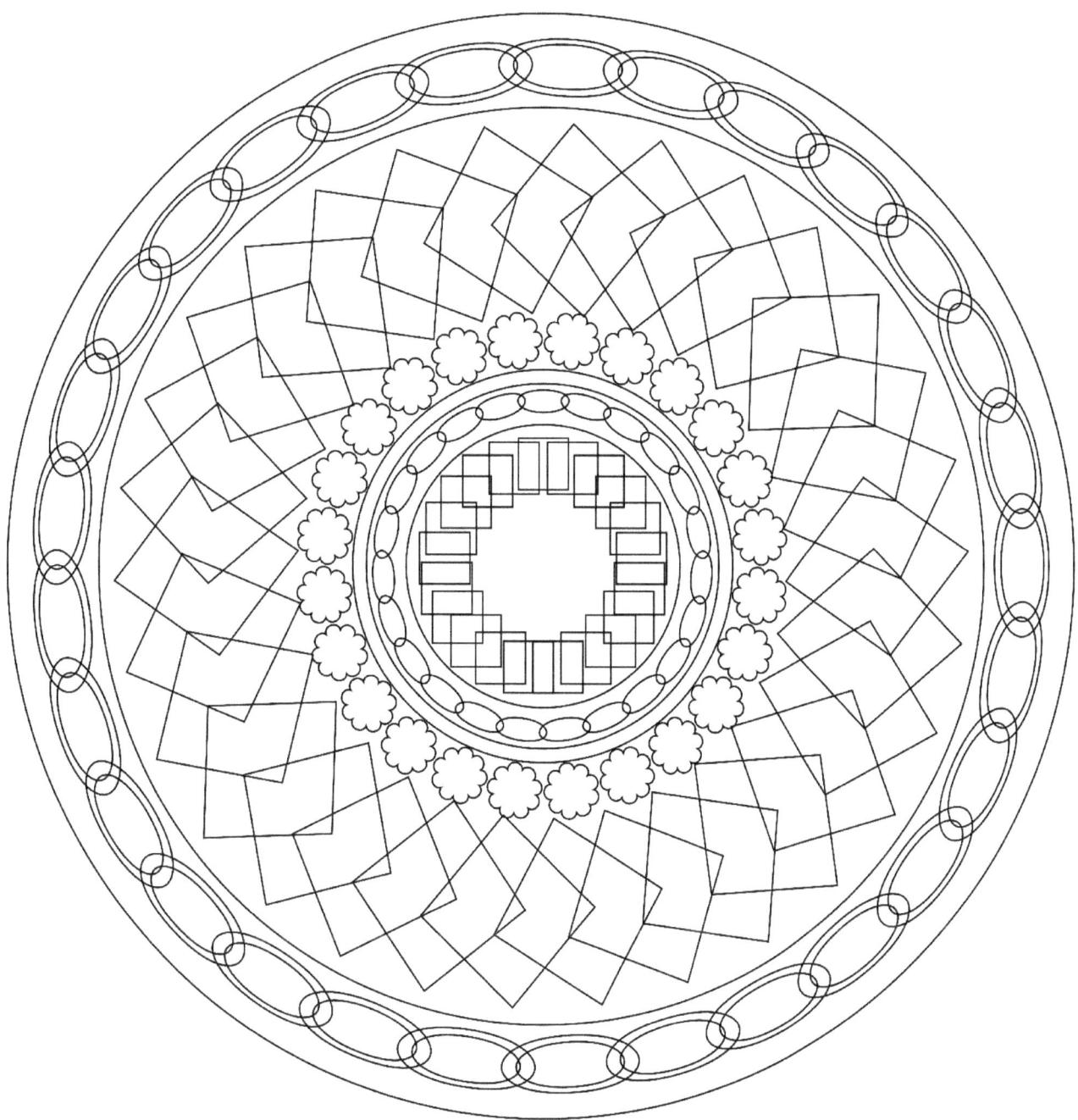

"How wonderful it is that nobody has to wait a single moment before starting to improve the world."

- Anne Frank

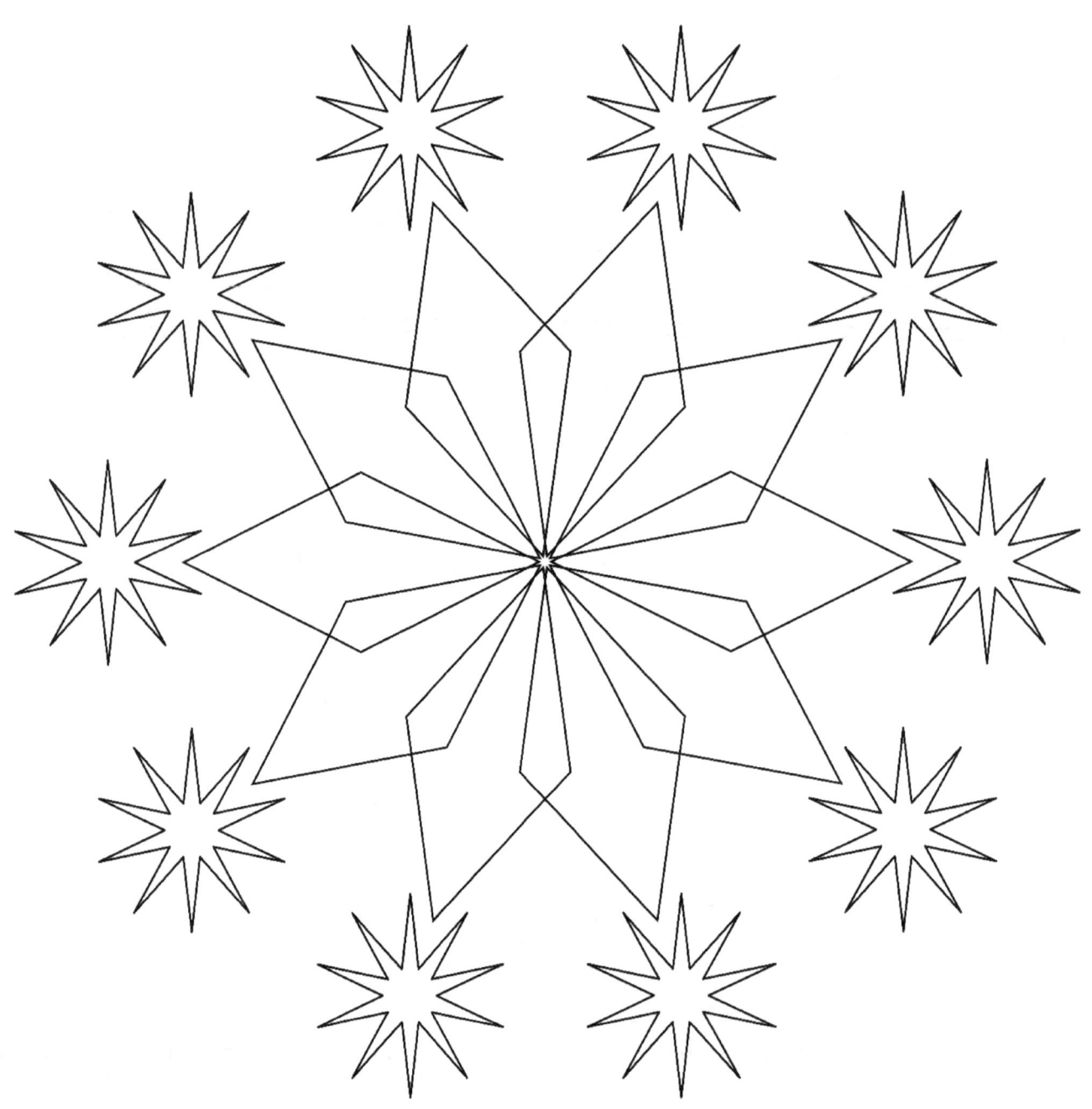

"Painting is a means of self-enlightenment."
-Unknown

The Secret Life of Mandalas: A Coloring Book with Inspirational Poetry

"The only time I feel alive is when I am painting"
-Vincent Van Gogh

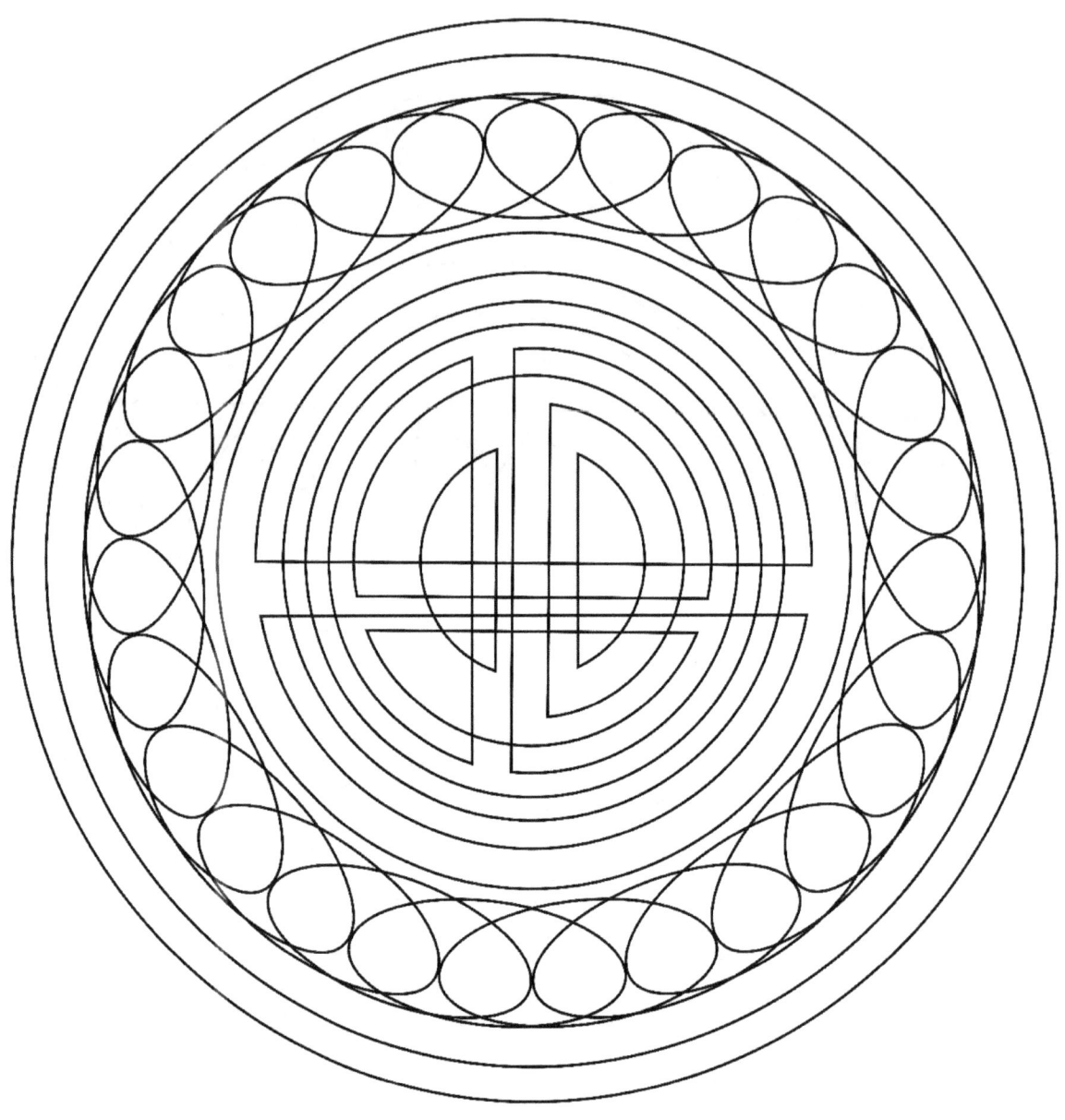

"What God intended for you goes far beyond anything you can imagine."
- Oprah Winfrey

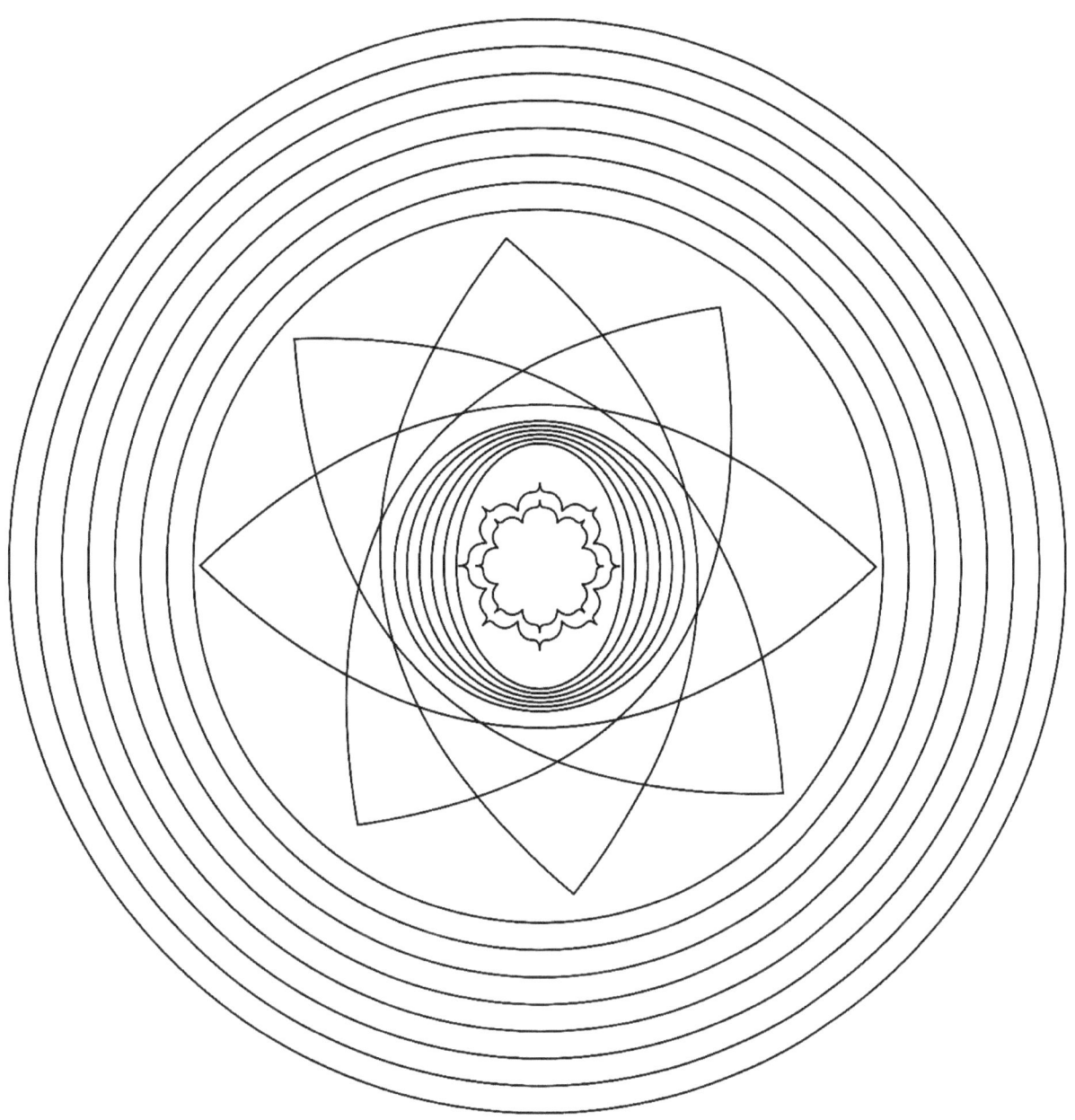

"The most common way people give up their power is by thinking they don't have any."

-Alice Walker

# Draw Your Own Mandala

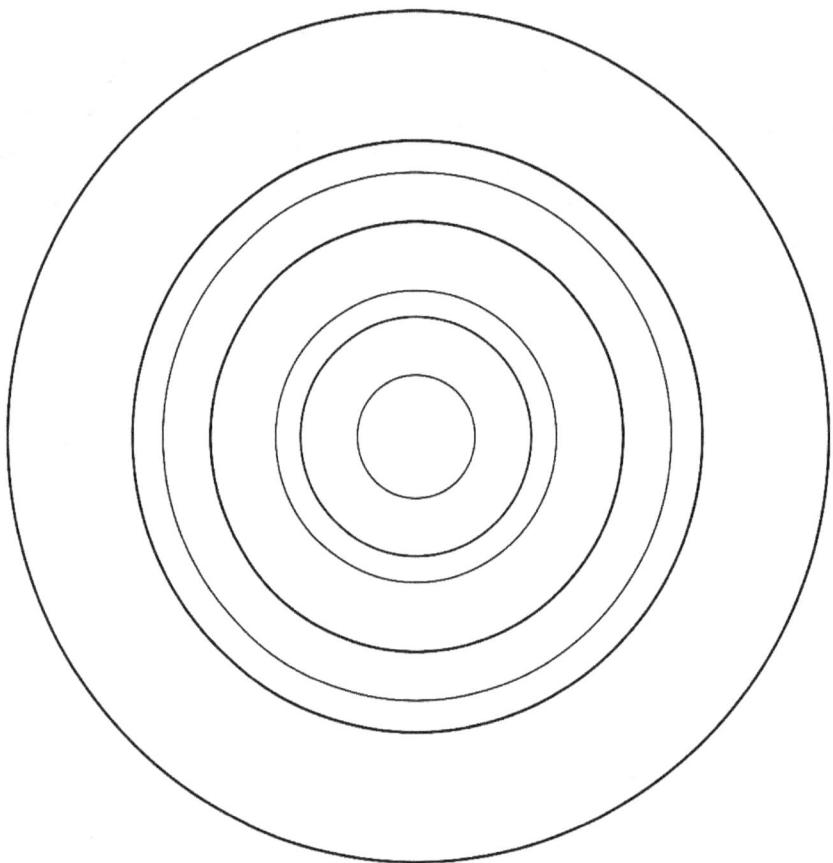

"I try to apply colors like words that shape poems, like notes that shape music."
- Joan Miro

Melba Christie

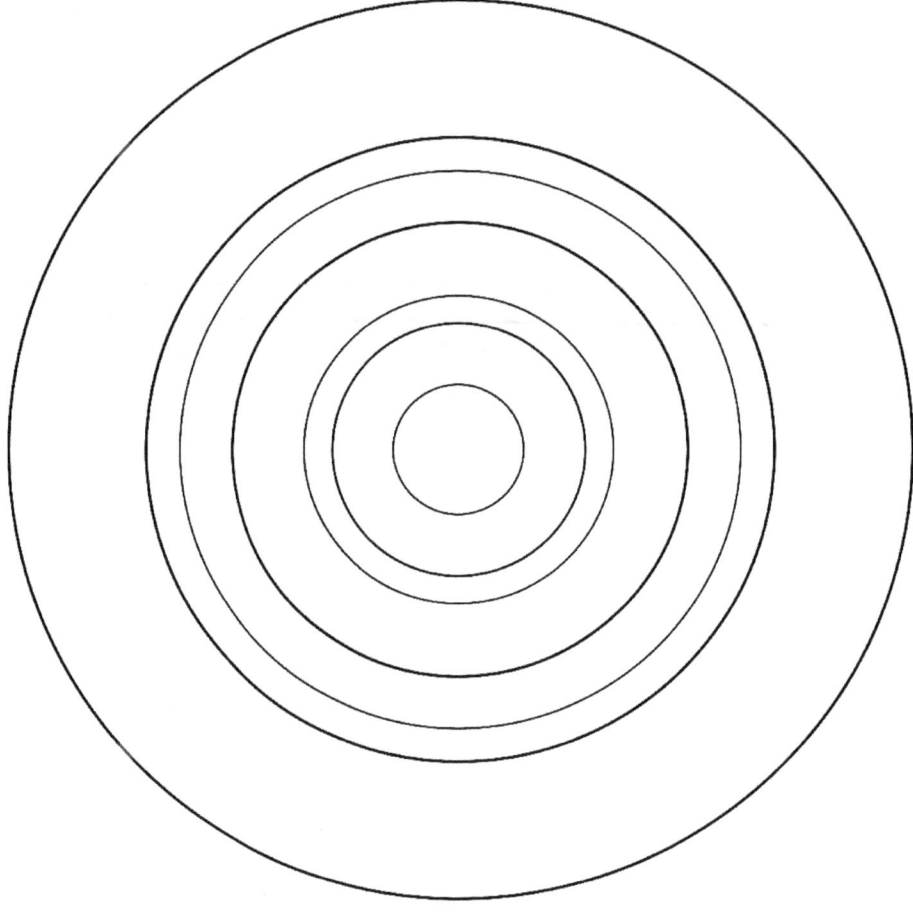

# References Books

- ❖ Mandala: The Art of Creating Future by June-Elleni Laine

- ❖ The Theory and Practice of the Mandala by Giuseppe Tucci

- ❖ The Mandala Book: Patterns of the Universe by Lori Bailey Cunninghan

- ❖ Mandala: Luminous Symbols for Healing Paperback by Miron Cornell

- ❖ The Mandala Guide Book: How to draw, paint, and color expressive Mandala art by Kathryn Costa

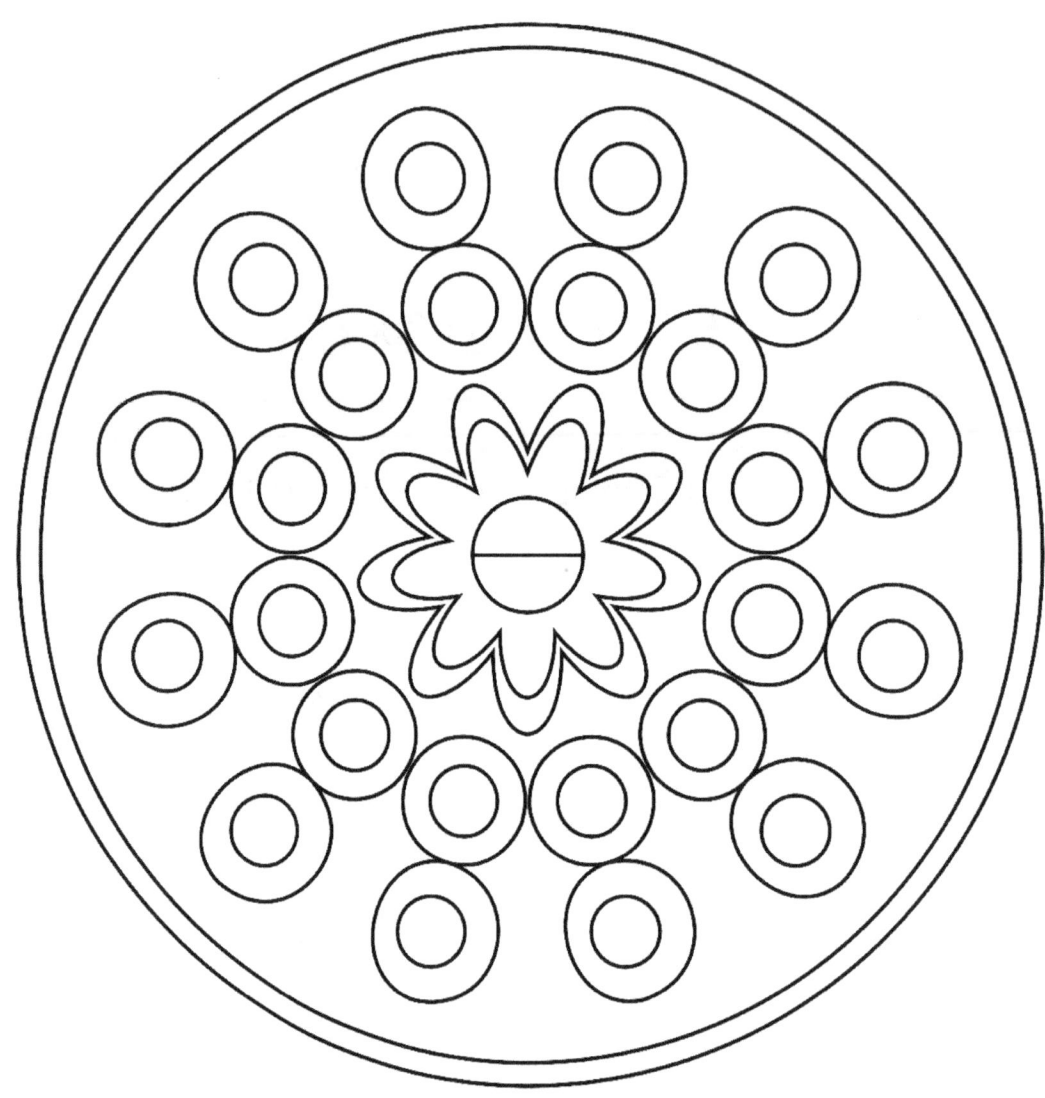

"Que no conozca el significado de mi arte, no significa que no lo tenga."
Salvador Dalí

www.ingramcontent.com/pod-product-compliance
Lightning Source LLC
Chambersburg PA
CBHW080724190526
45169CB00006B/2507